Romantic
Landscape
Vision
CONSTABLE AND WORDSWORTH

Romantic Landscape Vision

CONSTABLE AND WORDSWORTH

Karl Kroeber

*The University
of
Wisconsin
Press*

Published 1975
The University of Wisconsin Press
Box 1379, Madison, Wisconsin 53701

The University of Wisconsin Press, Ltd.
70 Great Russell Street, London

First printing

Printed in the United States of America

For LC CIP information see the colophon

ISBN 0-299-06710-6

This publication has been aided by a grant from The Carl and Lily Pforzheimer
Foundation, Inc.

To Mishka

Contents

Illustrations

ACKNOWLEDGMENTS

Portions of the first, second, and sixth chapters appeared in some-
what different form in, respectively, the *Journal of the Warburg
and Courtauld Institutes* (vol. 34), the *Journal of Aesthetics and
Art Criticism* (vol. 31, no. 1), and *PMLA* (vol. 89, no. 1), and I am
grateful to the editors of these journals for permission here to re-
cycle my criticism. Errors of fact and eccentricities of interpreta-
tion are my responsibility. Whatever of wisdom and accuracy is in
the following pages owes much to colleagues at Columbia Univer-
sity. James L. Clifford tried to improve my understanding of
eighteenth-century poetry and politics. Joseph A. Mazzeo and
Edward W. Tayler shared with me their extensive knowledge of
seventeenth-century art, science, and philosophy. My indebtedness
to Carl R. Woodring and Martin Meisel is incalculable. I am grateful
also to Donald Reiman at the Carl H. Pforzheimer Library for psy-
chological (and other) encouragement at crucial moments. Mr.
Leslie Parris at the Tate Gallery offered me more cooperation in
finding Constable material than I was able to take advantage of,
and I am pleased to acknowledge his helpful friendliness. I thank
Professor Russell Noyes for allowing me to use for the jacket of
this book a reproduction of his superb photograph of Grasmere
Vale which served as frontispiece to his *Wordsworth and the Art of
Landscape* (Bloomington: Indiana University Press, 1968).

Karl Kroeber

New York
May 1, 1974

Romantic
Landscape
Vision

CONSTABLE AND WORDSWORTH

1
Spots of Time and
The Haywain

A presupposition underlying most debates about "Romanticism" is that the word—if meaningful—labels a pattern. It is difficult, for example, to resolve the disagreement between Wellek, arguing for one Romanticism, and Lovejoy, arguing for discriminated romanticisms, because both scholars assume that at issue is a relatively abstract pattern, and they disagree only in their interpretations of the evidence.[1] But the term may refer to something more involuted,

1. The argument was begun by A. O. Lovejoy's essay "On Discrimination of Romanticisms," *PMLA* 29 (1924): 229–53 (later reprinted in *Essays in the History of Ideas* [Baltimore, 1948]). René Wellek's most significant rejoinder is to be found in his two-part essay "The Concept of Romanticism in Literary History," *Comparative Literature* 1 (1949): 1–23, 147–72. A more recent restatement of his position, in which he also defends himself against some oversimplifications of his view, is "Romanticism Re-examined," in *Romanticism Reconsidered,* ed. Northrop Frye (New York and London, 1963), pp. 107–33. A good introduction to the interconnected problems of finding analogies between the arts, of relating their histories, of adjusting their different periodizations, and of evaluating the aesthetic/philosophic justifications (e.g., theory of Zeitgeist) for comparing them will be found in a collection of ten essays in *New Literary History* 3, no. 3 (Spring 1972), devoted to the topic of "Literary and Art History." Of special value are the essays of Jean Laude, "On the Analysis of Poems and Paintings," pp. 477–86, James Bunn, "Circle and Sequence in the Conjectural Lyric," pp. 511–26, and Oleg Grabar, "History of Art and History of Literature: Some Random Thoughts," pp. 559–68. Documentation for

3

even indeterminate, than they suppose, an order dialectically consti-
tuted, combining symmetries and dissymmetries among disparately
autonomous elements. Whether or not Romanticism is to be de-
fined by generalized, pseudoscientific terms such as "organicism"
seems to matter little—and debating the point may divert us from
confronting a sensibility actualized in specific art works created
two centuries ago.

Such confronting is historical criticism: to perceive feelingly what
William Wordsworth termed "similitude in dissimilitude" and what,
a century later, Paul Valéry called a vital form's autonomy from its
symmetrical counterparts.[2] Wordsworth and Valéry have little in
common, but they share a desire to understand how the present
may best come to terms with its past. And their observations co-
here in suggesting that an aesthetic historian needs an intricate
double awareness, not only of what in Valéry's terms is the "dis-
symmetrical congruence" of each work of art to its artistic context
but also of the difference—even antagonism—between the sensibility
of the present day and that of an earlier period.

Looking for a way of sustaining this complicated alertness, I
thought to study simultaneously landscape poetry and landscape
painting in Britain during the first years of the nineteenth century.
Disparate and autonomous arts discourage generalizing about con-
sistency; limited subject matter compels attention to alien specific-
ities in particular art works. My contrapuntal analyses cannot de-
fine, in Wellek-Lovejoy fashion, what Romanticism *was,* but they
may embody, however idiosyncratically, a significance two-century-
old art retains—even if that be only recognition of why it must now
be out of fashion.

I concentrate on a few poems and paintings by William Words-

these essays provides references to most of the principal theoretical discussions of art-
literature relations by scholars such as Ackerman, Arnheim, Francastel, Gombrich, Ivins,
McLuhan, Panofsky, Praz, Schapiro, Wellek, and Wölfflin. A fine volume of specific com-
parisons is *Encounters,* ed. John Dixon Hunt (New York, 1971).

2. The essay of Valéry's to which I refer most specifically is "L'Homme et la coquille,"
first published in 1937 and available in a fine translation by Ralph Manheim, *Collected
Works of Paul Valéry,* vol. 13, *Aesthetics,* ed. Jackson Matthews (New York, 1964), pp.
3–30. Many of Valéry's essays on aesthetics focus on the concept of dissymmetry. In
the Appendix I have tried to indicate something of the depth and intricacy of the
Romantics' debt to their immediate predecessors, a debt which my method of analysis
tends to obscure.

worth and John Constable, so it may be helpful to begin with reference to part of their background, the aesthetics of the picturesque. No one doubts that both were affected by the taste for picturesqueness which flourished during the late years of the eighteenth century, and which, as a symptom of man's changing relations to the natural world, merits attention.[3] At the beginning of the eighteenth century "picturesque" described a natural scene that looked as if it were derived from a picture, nature reminiscent of artifice. Gradually the meaning shifted toward reference to landscape that *ought* to be pictured, a scene that was a potential subject, a source, for creation of an art work.

Even so rapidly summarized, the history of the term picturesque distinguishes it from two other key words in eighteenth-century aesthetics, "sublime" and "beautiful." Essential to it but not to them is "feedback." A discussion of beauty (or of sublimity) may be directed exclusively to beauty (or sublimity) in nature or exclusively to beauty (or sublimity) in art; it may relate art and nature, but need not do so—which is why most such discussions, in fact, endeavor to establish a connection between nature and art. In discussing the picturesque, however, one must speak of both art and nature, because the term refers to a relation between them. The emergence of the concept of the picturesque indicates something new in aesthetic consciousness, a disposition to conceive of both the natural and the artificial less as absolutes than as terms of an interactive relation.

The picturesque encouraged descriptive writing: Gilpin described scenes with both pen and pencil.[4] Under the aegis of the picturesque,

3. Picturesqueness has been much studied. Among older works on the subject, Elizabeth Wheeler Manwaring, *Italian Landscape in Eighteenth-century England* (1925; reissued, London, 1965—still a good source for poets like Thomson's knowledge of pictures), Christopher Hussey, *The Picturesque* (1927; reissued, London, 1967), and W. J. Whipple, *The Beautiful, the Sublime, and the Picturesque in Eighteenth-Century British Aesthetic Theory* (Carbondale, Ill., 1957), are notable. More recent studies include several chapters in Nicholas Pevsner, *Studies in Art, Architecture and Design* (London, 1968), Martin Price's stimulating essay, "The Picturesque Moment," in *From Sensibility to Romanticism*, ed. H. W. Hilles and Harold Bloom (New Haven, 1965), pp. 271–92, E. Malins, *English Landscaping and Literature* (London, 1966), Russell Noyes's book cited in note 9 below, and J. R. Watson's sensible and judicious *Picturesque Landscape and English Romantic Poetry* (London, 1970). All these works contain references to original sources and to other relevant criticism.

4. Probably the most complete study of Gilpin and the best guide to his numerous

traditional inadequacies of language to pictorialize were disregarded, for language has special power in representing internal, psychological conditions, and these are important to picturesqueness. To see the artistry, actual or potential, intrinsic to a natural scene is, one might say, to become aware of how psychological states *enter into* nature. There is, indeed, a parallel between the development of picturesque aesthetics and the development of the Romantic concept of imagination, particularly the projective imagination. During the eighteenth century "imagination" evolved from association with the idea of "imitation" toward association with "creation," a development connected with the shift (carefully traced by M. H. Abrams) from the conception of art as a mirror to art as a lamp.[5] And this transformation involved a change in primary connotation of "imagine" from "copying," mentally reconstructing external actualities, to "creating," mentally fabricating actualities. The picturesque, encouraging alertness to interactive relations between the natural and the artistic, the physical and the psychological, develops analogously, from reference to scenes reminiscent of paintings (or styles of painting) toward reference to scenes suggestive of pictures that could be fabricated.

I do not mean to exaggerate the importance of picturesque art, little of which is of high quality. And most of its theorists were second-rate intellects. Yet the cult is a feature of the context out of which Romantic art emerges, even though Romantics often reacted against picturesqueness. In *The Prelude,* for example, Wordsworth treats his own fondness for the picturesque as part of his imagination's impairment.[6] He says that the picturesque not only

works is C. P. Barbier, *William Gilpin* (Oxford, 1963); see especially the valuable chapter 8, "Theory of the Picturesque." Gilpin, incidentally, was the first, so far as I know, to distinguish between Milton as a musical poet and Thomson as a descriptively picturesque one—see *Observations on . . . the Mountains and Lakes of Cumberland and Westmoreland,* 3rd ed. (London, 1808), 1: 184–85.

5. M. H. Abrams, *The Mirror and the Lamp* (New York, 1953).

6. *The Prelude,* 1805, bk. 11, ll. 152–64:

> even in pleasure pleas'd
> Unworthily, disliking here, and there,
> Liking, by rules of mimic art transferr'd
> To things above all art. But more, for this,
> Although a strong infection of the age,
> Was never much my habit, giving way

encouraged superficial judgment to "interrupt" his "deeper feelings" but produced a state "In which the eye was master of the heart." To understand Wordsworth's attitude, we should remember that, in part, Romantic poetry reacts against descriptive prose. Poets in the late eighteenth century, unlike their predecessors, had to compete with prose aiming to be both pictorial and evocative. Graphic artists had to compete with prose and poetry, and the challenge led them into self-examinations perhaps as significant as those caused by the invention of photography in the next century. If literature could enter into what had been the exclusive domain of painting, it was incumbent upon graphic artists to reevaluate their special function and the special attributes of their art. Turner's work, to cite the obvious example, is a redefining of the nature of painting, a redefinition which in fact brings to a climax a century of debate. During the eighteenth century a major critical-theoretical issue was how boundaries between the arts might appropriately and securely be delineated—Lessing's *Laokoon* being but one, though probably the best known, of the products of this controversy.[7] In the light of

> To a comparison of scene with scene
> Bent overmuch on superficial things,
> Pampering myself with meagre novelties
> Of colour or proportion, to the moods
> Of time or season, to the moral power
> The affections, and the spirit of the place,
> Less sensible.

All quotations from *The Prelude* are from the 1805 text of *William Wordsworth: The Prelude,* ed. Ernest de Selincourt, 2nd ed., rev. Helen Darbishire (London, 1959). As I suggest in chapter 5, sound is crucial to Wordsworthian landscapes. Romantic poets' resistance to the picturesque is founded, I believe, on their reversal of the usual eighteenth-century ranking of painting above music and poetry, as is implicit in most neoclassic observations on *ut pictura poesis.* The first significant critical articulation of the Romantic view that I know is Rousseau's *Essai sur l'origine des langues,* especially the remarkable sixteenth chapter, "Fausse analogie entre les couleurs et les sons."

7. Jean H. Hagstrum, *The Sister Arts* (Chicago, 1958), should be consulted, as well as Rensselaer W. Lee, *Ut Pictura Poesis: The Humanistic Theory of Painting* (1940; reissued, New York, 1967), the latter concentrating on the sixteenth and seventeenth centuries (and see chapter 4, note 10, below). Although Irving Babbitt is out of fashion, his *The New Laokoon* (Boston and New York, 1910), esp. pp. 3–57, is still valuable. An essay carrying the topic into other aspects of Romantic art is Roy Park's " 'Ut Pictura Poesis': The Nineteenth-century Aftermath," *Journal of Aesthetics and Art Criticism* 28 (1969): 155–64. More theoretical in orientation and more general in scope (and more opinionated) is Mario Praz, *Mnemosyne: The Parallel Between Literature and the Visual Arts* (Princeton

debates over *ut pictura poesis,* it is tempting to see the Romantic period as one in which all proper boundaries were recklessly violated. Walter Scott's historical novels are crammed with verbal descriptions (although Scott by his own admission was incapable of drawing), and Turner favored heroically literary subjects and frequently attached to his paintings excerpts from *The Seasons,* or from his own semiliterate poems. These interpenetrations, however, are not signals of transient confusions. Scott appears to have dealt a deathblow to traditional historical painting, because he showed that literature could more effectively than painting render some kinds of complex historical truth. And Turner proved that painting could effectively represent that which is not distinctly visible.

To such advances, and others like them, the picturesque may have contributed most significantly (though not most obviously) by encouraging awareness that how we perceive and what we perceive is to a degree predetermined, as modern psychologists say. Art as a predeterminer of what we perceive in nature is illustrated by the apocryphal story of Constable laying a violin on a lawn to dramatize for a Claude-enthusiast the true color of grass. Not apocryphal is Constable's refusal to adapt without major modification the compositional models provided by his predecessors, even though he laid small claim to personal originality, stressing, rather, his fidelity to nature. For Wordsworth, predeterminedness was important and complicated, as is suggested by his equal allegiance to spontaneity and memory. Resisting "rules of mimic art," the distorting of true responsiveness to nature induced by picturesque theorizing, he nevertheless insisted on a proper predisposing of understanding and sensibility as essential to worthwhile representations of nature. He attacked conventional attitudes toward the natural world not simply because they prevented spontaneous responsiveness but also because they predetermined the mind in the wrong fashion. Once awareness arises that predeterminedness is a problem, many of the

1970). Even more theoretical and inclusive is Morse Peckham, *Beyond the Tragic Vision* (New York, 1962), of special interest to readers of this book being chapter 6, on Wordsworth and Goethe, and chapter 8, on Friedrich and Constable. Wylie Sypher, *Rococo to Cubism in Art and Literature* (New York, 1960), attempts to cover too much ground but upon occasion makes perceptive comments.

old aesthetic controversies, such as that of the relation of manner to matter, take on new dimensions. Genre, for instance, becomes an intriguing subject for experimentation rather than merely an accepted mode of procedure.[8]

So much for complexities beyond this study's scope. My purpose is not merely to establish analogies between the art of Constable and Wordsworth but also to identify differences. So to distinguish is to do justice to both—and is necessary to a comprehension of their shared style. Adequately to appreciate one, we must recognize the force of the alternatives embodied in the work of the other. Romanticism is a coherence of alternatives, as is, say, "the" Renaissance; to understand it at all is to understand an indeterminate, even contradictory, phenomenon. I spend little time, therefore, tracing out possible influences of one artist upon the other, and disregard obvious comparisons, as, for example, between Constable's paintings of Sir George Beaumont's cenotaph and Wordsworth's several Coleorton poems. Nor do I dwell on either's comments about his own work or about the other arts.[9] I begin with a

8. Analogous to developments within genres are developments of relations between arts, witness William Blake. I say little of his work here because I hope to discuss it in connection with Turner's art in a later study. Turner and Blake epitomize a basic Romantic contradiction, that between line and blot styles.

9. Among more than casual comparisons, R. F. Storch's "Wordsworth and Constable," *Studies in Romanticism* 5 (1966): 121–38, is perhaps the most profound. Russell Noyes, *Wordsworth and the Art of Landscape* (Bloomington, 1968), pp. 64–86, presents a sensible survey of the artists' relations. Kurt Badt's fine book *John Constable's Clouds*, English trans. Stanley Goodman (London, 1950), includes astute observations upon analogies between poet's and painter's aims. J. R. Watson, "Wordsworth and Constable," *Review of English Studies* 13 (1962): 361–67, describes the meetings of poet and painter and evaluates the nature of their personal relations judiciously. Martha Hale Shackford, *Wordsworth's Interest in Painters and Pictures* (Wellesley, Mass., 1945), is still valuable. Chapter 6, "Wordsworth and Constable," in Morse Peckham's *The Triumph of Romanticism* (Columbia, S.C., 1970) provides a stimulating comparison, though other scholars have not supported Peckham's claim that Constable's art underwent a decisive change in 1808. Although not concerned with Constable, Alec King in his fine *Wordsworth and the Artist's Vision* (London, 1966) studies the poet in the light of principles of graphic art. I hope my work may help to open new avenues for exploring the significance of artists' comments upon sister arts and also the complex fashion in which a painter's response to poetry (or a poet's to painting) may be usefully evaluated. I call attention more than once in this study to the difficulty of assessing Constable's seemingly contradictory comments. For example, reporting on French criticism of his works (which, though acclaimed when they were exhibited in 1824, most notably by Delacroix and Stendhal, were also attacked by French critics) Constable quotes a judgment—apparently of *The Haywain*—as "like the

simple pairing, Wordsworth's "spots of time" passage in *The Prelude* and Constable's best-known painting, *The Haywain,* trusting that results of the analyses will form a basis for more complex comparison-contrasts.

Although many commentators have linked Wordsworth's and Constable's names, the natural scenes they represent could scarcely be more different. Constable did paint some views of the Lake District, but the pictures upon which his fame rests are of scenes unlike those Wordsworth describes in his best poetry. Wordsworth never depicts a rural farming scene, or a canal. Constable virtually never strives for "visionary dreariness." In their subject matter the two artists differ as the landscapes of Cumberland and East Anglia. Any similitude between their work must be within this dissimilitude of subject matter as well as within the dissimilitude of poetry and painting.

In the 1805 text of *The Prelude* the "spots of time" passage runs from line 258 through line 389 of bk. 11,[10] nearly half these lines being devoted to reflection and comment upon two incidents and their function in mnemonic processes. Of the commentary the largest consecutive unit is lines 316–43, inserted (probably in 1804) by Wordsworth between accounts of the two incidents (probably composed in 1800). Even in the 1805 text, then, narration is not "pure" but serves a complex function. Wordsworth begins by as-

rich preludes in musick, and the full harmonious warblings of the Aeolian lyre, which *mean* nothing . . ." and goes on to retort, "Is not some of this *blame* the highest *praise*—what is poetry? What is Coleridge's Ancient Mariner (the best modern poem) but something like this?" (letter to Fisher, 17 December 1824, *John Constable's Correspondence,* ed. R. B. Beckett, 6 vols. [London, H.M. Stationery Office, 1962–66; also issued by the Suffolk Records Society, Ipswich, as volumes 4, 6, 8, 10–12, of its publications], 4: 192–93. Pages 177–211 of volume 4 contain an excellent account of the history of Constable's pictures in France.)

10. Two of the many analyses of this famous passage to which my criticism is most indebted are Herbert Lindenberger, *On Wordsworth's Prelude* (Princeton, 1963), esp. pp. 143–47, and Geoffrey Hartman, *Wordsworth's Poetry 1787–1814* (New Haven and London,, 1964), esp. pp. 211–19. A summary of stylistic differences between the 1805 and the 1850 versions, with ample references to others who have commented on the differences will be found in Lindenberger, pp. 295–99. More recently, Jonathan Wordsworth, "The Growth of the Poet's Mind," *Cornell Library Journal* 11 (Spring 1970): 22–24, argues for the superiority of the earliest version of the passage, and Sybil S. Eaken, "The Spots of Time in Early Versions of *The Prelude,*" *Studies in Romanticism* 12 (1973): 389–405, usefully brings together manuscript evidence about Wordsworth's revisions of the passages.

serting that the occurrences are "Among those passages of life" which "retain/ A vivifying Virtue" because they convey the "deepest feeling that the mind/ Is lord and master, and that outward sense/ Is but the obedient servant of her will." The illustrativeness of the incidents is peculiar. Of the girl with the pitcher on her head, Wordsworth says there is no language able to portray the "visionary dreariness" which "Did . . . invest" that "ordinary sight." The illustration is illustratively inadequate. The poet pictures what cannot be pictured, so comment is necessary.

In the inserted passage, lines 316–43, moreover, Wordsworth tells us that when "long after" he "roam'd about" in the "presence of this very scene" the "golden gleam" of pleasure and youth fell on the spot "with radiance more divine" because of the "remembrances" of the earlier events "and from the power/ They left behind." One would not expect "dreariness," even of a visionary kind, to increase radiance. The poet is illustrating paradoxical, mysterious processes which render language ineffective to convey what he wants to convey. "So," he continues, "feeling comes in aid/ Of feeling, and diversity of strength/ Attends us if but once we have been strong." It is difficult to know what "strong" means here—"been strong" suggests something more than having had strong feelings. But such imprecision is essential because Wordsworth is concerned with the "mystery of Man." The poet is "lost" but sees in "childhood" the "base" of man's "greatness" and feels "That from thyself it is that thou must give,/ Else never can receive." Although the "days" of his earliest youth "come back" upon him and "the hiding-places" of his "power/ Seem open" (the hiding-places recalling the "depth" from which "Proceed" the "honours" of "Man"), at his "approach" the hiding-places close. His vision is now imperfect ("I see by glimpses now") and while he "may, as far as words can give," he would "give . . . A substance and a life" to what he feels, thus to "enshrine the spirit of the past/ For future restoration," because he fears that "when age comes on" he "may scarcely see at all."

The spot of time which is first said to "retain/ A vivifying Virtue" appears capable of losing its "efficacious power." Wordsworth says that he *now* wants to preserve, make permanent, "enshrine," his present sense of the vitality of his memory because he recognizes it to be weaker than it was and that, therefore, "as age comes on" it may vanish. A celebration of

memory has become a representation of the tendency of memory to fail.

The word "enshrine" refers back to Wordsworth's faith that "the mind is lord and master," that something beyond the physical is involved in significant experiences, even those of "simple childhood." But the ability to "enshrine" is made problematic by his insistence on the inadequacy of language to capture and preserve what is beyond natural appearances. His accomplishment is to convey both the "feeling that the mind/ Is lord and master" and the feeling that the mind does fail.

Grim overtones of the first incident carry across to the second through the bleakness of the scene and its connection with Wordsworth's father's death, although it seems to me that it is the paradoxical development-deterioration of the mind's mysterious power which more closely links the two events. The climactic revelation of the second episode is that in later years in other circumstances "unknown to me/ The workings of my spirit thence are brought"— "thence" apparently referring to his memories of the vigil on the crag. The agency that brings the "workings" of the poet's "spirit" is unidentified, even as he is not fully conscious of the transformation of his spiritual actions. Here it would seem that language is necessarily inadequate to the mystery Wordsworth would convey. All that is confirmed is that there is a psychic continuity which works against the declines and losses of time.

For modern readers Wordsworth's presentation of continuity is disturbing because it suggests a Freudian perspective upon human experience but simultaneously strikes us as radically different from Freud's view. Wordsworth, like Freud, emphasizes the paramount importance of seemingly trivial childhood events, but the poet locates their importance in their nontraumatic quality. They matter because they can be recalled. Though intrinsically "mysterious" they are not concealed. Freud sees trivial events as not mysterious, rationally explicable, but hidden, that is, repressed.

For Wordsworth individual personality is shaped by its active continuity, the mode in which workings of the mind connect different temporal segments of life. It may be objected that in *The Prelude* Wordsworth portrays the development of a healthy personality; he might agree with Freud that a diseased personality is distorted by its repressions, symptoms of the broken continuity of the

well-integrated psyche. To put it the other way around, is not Freud's healthiest personality the one with fewest repressions? The question is not easy to answer, because Freud has so little interest in healthy personalities (whereas Wordsworth is not so interested in diseased ones). In Freud's view, it is fair to say, everyone is threatened by his unconscious, by unmysterious but repressed experiences, the ill effects of which can be mitigated only by rational analysis. Freudian therapy in a very real sense exorcizes the child in the man—exactly what Wordsworth wanted to preserve. He believes, literally, that "highest truth" dwells in the depths of childhood from which man's "honours" arise. From the vital process itself springs the mysterious fountainhead of human achievement, a diversity of strength, toward which poetry directs our attention by its very failure to picture what it would have us recognize. It is the poet's bafflement which leads us through sight to insight; poetic vision sustains us even as it fails.

The formal difference between Freud's rational analyses and Wordsworth's poetic revelations is keyed by their antithetical cosmologies. Freud sees life as an accidental phenomenon in a universe whose basic characteristic is lifelessness.[11] Wordsworth sees death as an accidental disruption of the eternal continuity which is the essence of a living cosmos. Freud's view is pessimistic; the stoic courage with which he confronts the bleakness of his own reasoning is perhaps his most admirable quality. He never flinches from the darkest implications of his own thought. But his view is not tragic. Tragedy is what his analysis removes from the Oedipus story.

Wordsworth's optimism permits him a more heroic and tragic conception. What his poetry reveals is man's awareness (dramatized by his mnemonic powers) making possible a richer, because a more fully interactive, participation in the continuity that is life. Simultaneously, awareness carries with it the recognition that the individualism resulting from mnemonic power (the power which makes man, in fact, the most vital of living things) will diminish. The individual must die. The price of attaining the highest potency of which life is capable, consciousness, is understanding that particular potencies

11. "At one time or another, by some operation of force which still completely baffles conjecture, the properties of life were awakened in lifeless matter" (Sigmund Freud, *Beyond the Pleasure Principle*, The International Psycho-Analytical Library, no. 4 [London and Vienna, 1922], p. 47).

fail and perish. Freud finds a grim destiny for both the individual and the species foreshadowed in the traumas of childhood. Wordsworth finds in the joy-giving power of recollection evidence that his losses as an individual affirm man's role as the most active participant in universal life. Freud's rigorous logicality leads him finally to rationalize the illogicality of mere inertness (the death instinct).[12] Wordsworth's poetic language testifies to a permanent vitality by revealing its own inadequacy. For him the failure of language, like the failure of the individual, points toward a potential adequacy, a grander success.

This opposition derives, as I have said, from Freud's and Wordsworth's understanding of the nature of the universe, and it is at this profound level that one finds the closest association of Wordsworth and Constable. Superficially their landscapes are unalike; yet Constable's pictures do not yield much reward to Freudian analysis. In the ordinary terminology of criticism *The Haywain* shares with Wordsworth's barren scenes a certain simplicity. Indeed, the picture is so simple, and so simply charming, that a modern critic is inclined to wonder if it can be significant art.[13] This simplicity, or accessibility, merits attention. In the "spots of time" passage Wordsworth deals with a familiar phenomenon, even though we have never had experiences identical with his, may never even have seen a northern moorland. But we all have childhood memories. Constable's scene is accessible in the same fashion. It looks ordinary and commonplace even today when few of us have actually seen such sights. It is familiar as a spot of time.

12. Ibid.; see also *Civilization and Its Discontents,* The International Psycho-Analytical Library, no. 17 (London, 1930), passim.

13. My focus is subject matter. In Constable's own time it was contrast between unusual technique, e.g., bright colors, and subject matter which aroused strong critical reactions, often hostile but sometimes favorable, as in the French reviews (see note 9, above). Among the most valuable studies of Constable's art, besides Badt's work cited above, are E. H. Gombrich's superb *Art and Illusion,* 3rd ed. (London, 1968), especially pp. 29–34, 150–52, 265–71, 320–29, and Kenneth Clark's comments in *Landscape into Art* (Boston, 1961), pp. 74–80. Like all students of Constable, I am indebted to Graham Reynolds' *Catalogue of the Constable Collection at the Victoria and Albert Museum* (London, 1959) and to his judicious study *Constable: The Natural Painter* (London, 1965). Only after most of my commentary on Constable had been written did I encounter the brief but excellent introduction by Conal Shields and Leslie Parris to *John Constable* (London, 1969).

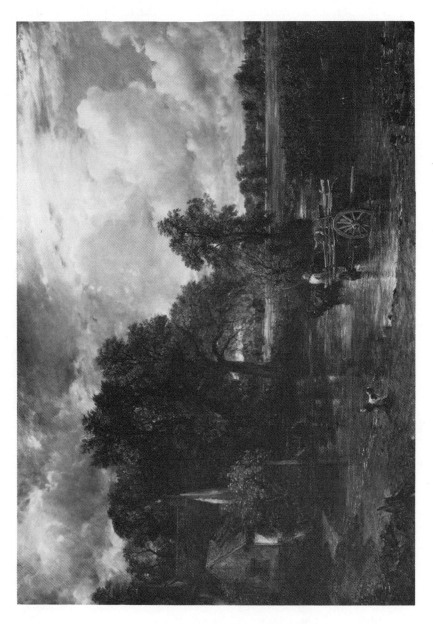

Constable, *The Haywain*. (Reproduced by courtesy of the Trustees, the National Gallery, London.)

The commonplaceness of the scene contains one oddity. The wagon is where one would not expect it, in the middle of the stream. Constable's picture is of a *passage,* as is suggested by its original title: *Landscape: Noon.* What is represented is a moment of transition. But the picture gives an impression of quiet, tranquility, even stasis: the moment of passage evokes a sense of continuity. Analogously, *The Prelude* passage represents less the isolated quality of the spots of time than their beneficent function in connecting disparate phases of life, their "vivifying Virtue" springing from their contribution to the continuity of psychic experience.[14] Constable's moment of passage from morning to afternoon creates in us consciousness of the persisting rhythms of life.

Wordsworth speaks of his inability to "paint" the visionary dreariness which invests the moorland scene. Constable has no means directly to plead the inadequacy of his medium. Yet perhaps he makes an analogous plea through the very completeness of his painting. Critics have pointed out that all portions of a picture such as *The Haywain* are carefully painted.[15] Nothing is slighted. Nothing is out of focus. Yet there is none of the microscopic accuracy we find, for example, in a Van Eyck landscape. Magnified sufficiently, every shrub, leaf, even every blade of grass, appears to have been depicted accurately by Van Eyck. Equal magnification of a background segment of *The Haywain* reveals blurriness. Constable's concern for each portion of his picture is care that details of light and shadow contribute to the effect of the picture as a chiaroscuro totality.[16]

14. A spot is an area distinguishable from, but not disconnected from, a surrounding area.

15. C. J. Holmes makes the point in *Constable and His Influence on Landscape Painting* (London, 1902), p. 174. See also Sir John Rothenstein, *Nineteenth-century Painting: A Study in Conflict* (London, 1932), and many of Constable's own comments, such as that to Fisher in a letter of 8 April 1826 about *The Cornfield:* "it is not neglected in any part" (*Correspondence,* ed. Beckett, 4: 216). A discussion of how Constable painted will be found in Richard and Samuel Redgrave's still useful *A Century of British Painters,* reissued in a new edition by Ruthven Todd (London, 1947).

16. Constable's references to "chiaroscuro" show that he meant by the term something slightly different from its conventional signification in his own day. The distinction can be indicated roughly by saying that Constable emphasizes the "light" half of the fusion. The importance he attached to this quality in landscape art is evidenced throughout C. R. Leslie's *Memoirs of the Life of John Constable*—the edition by Jonathan Mayne (London, 1951) is both handy and elegant—especially in the notes taken from Constable's lectures.

The equal integrity as light-and-dark elements of each part of *The Haywain* contributes to its mood, which is more significant than the ostensible subject. But one ought not to oversimplify Constable's moods. He preferred to painted finished versions of pictures for which he had made large, thoroughly painted sketches, which most modern critics regard as superior to the finished canvases. This modern taste depends in part on indifference to realistic detail. Constable, however, wanted such detail, especially chiaroscuro detail, just as he wanted to contain the Van Gogh-like vigor of his sketches within a controlled and carefully articulated unity. He had a marvelous sense for the texture of living things, but he wished to unite the vibrancy of particularities into a total harmoniousness whose quiet seems analogous to Wordsworth's "emotion recollected in tranquillity."

In Wordsworth's presentation of the girl with the pitcher we have the illusion that nothing has been omitted. This illusion Wordsworth often creates—it is connected to his preference for bare, unfecund places. The world of a poem or passage may not be rich, but we feel we are shown it all. Some readers find Wordsworth too fussy, too matter-of-fact. But for him, as for Constable, everything is important, central subject matter no more so than each detail of context. Constable spatially and Wordsworth temporally establish the special meaning of an event without diminishing the value of all to which the event is related. Both portray how things fit. *The Haywain* represents man *in* nature and man and nature's reciprocal interaction. The wagon is in the river, which is in part canal, the buildings are overgrown, the hewn posts implanted in the stream are worn by water action. These physical features embody the continuities of natural existence in a transient human action so that we respond both to a tranquility within movement and to a vitality within calmness. In different media Wordsworth and Constable create enduring images out of transitory events.

Neither Wordsworth's nor Constable's scenes are "impressions." There is a curious impersonality in *The Haywain*. Looking at the picture, one does not think of the painter; one is not conscious of a special point of view. The effect in part derives from Constable's diffusion of focus, his refusal to concentrate emphasis. Analogously, Wordsworth prevents us from responding to his sight of the girl as a mere impression by embedding the sight in a context of

subsequent memories and mental reflections. The point of view of which we are conscious is not that of the boy when he sees the girl but that of the adult poet toward the boy who had the vision. When one compares this technique with the tradition of topographical poetry upon which Wordsworth drew, one sees this as a key to his originality.[17] Wordsworth is concerned with connecting past and present; poetry is what connects them. Poetry arises in "tranquility" because it links memory to actual sensation. Since poetry thus connects external-physical to internal-psychic phenomena, it must fail as pictorialization, representation of appearances.

Constable diverges from the main tradition of landscape painting in a parallel manner. In the landscapes of Claude and even of the Dutch and Flemish realists much of the unity of scenes depends upon an underlying composition of geometrical forms. An important element in their harmoniousness is volumetric, mathematical. Constable seeks unity of mood. A mood is a pattern of feeling, but, we like to think, not merely a pattern imposed upon a specific environment but also expressive of some quality in the environment, a quality which subterraneously unites the various sensory impressions which make up the situation as a whole, the whole including the human in the situation.[18] A mood is not itself perceptible. The unity of mood cannot be painted directly as can a harmony of shapes or volumes. Wordsworth is being literal, matter-of-fact when he says that he cannot "paint" the "visionary dreariness" which "did . . . invest" the scene on the moor. Constable deals with a different mood in *The Haywain,* but he creates a unifying mood which is in itself unpaintable. What is not visible is as much

17. Wordsworth appears to follow rather literally Edmund Burke's suggestion in the final section of *A Philosophical Enquiry into the Origins of the Sublime and the Beautiful* that what ought to be portrayed in descriptive poetry is the poet's mind rather than the scene observed. See the edition of J. T. Boulton (London and New York, 1958), pp. 163–77. Boulton's introduction and notes are excellent.

18. Most of us feel that the "fearfulness" of a dark chasm in the mountains is in part objective, not solely the projection of our anxieties. Wordsworth and Constable come close to this popular view, perhaps because they are never concerned with perception in the abstract but only with specific perceptions of particular things. For them perception is interaction; hence their concern for the circumstances of interaction. Constable, for example, objecting to Eastlake's studies as "excellent of their kind" but "done wholly for the *understanding* bald and naked—nature divested of the 'chiaroscuro,' which she never is under any circumstances—for we can see nothing without a medium" (letter to Leslie, 26 September 1831, *Correspondence,* ed. Beckett, 3: 47).

at the heart of Constable's picture as at the heart of Wordsworth's poetry.

Contrary to what many of Constable's admirers say or imply, he did not copy natural appearances. There is reason for the painting of *The Haywain* having occupied him for months, much of the time in his studio. There is a good deal of mind in Constable's nature. Not only did he believe that one understands the earth by looking at the sky, but he also recognized the processes of nature as predominantly manifested in fluid, impalpable, unfixed phenomena. The foreground flat water of *The Haywain* reflects not so much the forms of objects as their colors and the colors of the sky. And the sky contains clouds, clouds carefully studied and meteorologically appropriate to the season, time of day, and the oncoming nature of the weather. Clouds are important to Constable because they embody changes of weather. Clouds are shapes of natural transitions, and as such their variousness is not random but the expression of complicated, dynamic principles. As Kurt Badt has shown, Constable's clouds are not decorative and not symbolic but real—real not in the sense of reproducing a specific cloud formation once seen but in the sense of being the type of cloud which would take shape in the conditions of the imagined scene. Constable's clouds are realistic, even though imagined, because his imagined shapes accord with the principles of meteorology and cloud formation.

Much Romantic art is realistic in this manner, imaginative creation in accord with the principles by which phenomena occur.[19] Yet Constable's clouds are not mere scientific illustrations. A cloud is by definition something that changes, and a major function of the clouds in *The Haywain* is to endow the still scene with movement, a context of sky processes connected with the water processes embodied in the slow-flowing stream. Linking these are trees (earth processes) which rise out of the water into the sky. In sum, *The Haywain* is the representation not so much of a genre scene as of the harmonious interaction of diverse life processes, including the animal and the human; it arouses our sense of a vital unity which imitation of discrete physical appearances would obscure. *The*

19. Badt, *John Constable's Clouds*, especially pp. 63, 66, 99, makes a strong argument for recognizing Constable's practice as "typical of the age."

Haywain will have little value for us, except as a jigsaw puzzle or brewery advertisement, unless we recognize that it renders Constable's vision *into* the life processes which are the essence of nature, into what cannot merely be seen but must be felt inwardly and must be understood "scientifically," that is, appreciated as a complex system of interdependencies.

Wordsworth presents us with the same kind of vision. He distinguishes the adult poet from the boy who experiences, so that the passage as a whole conveys not so much an impression as a representation of how sensation and recollection of sensation interact as a life process. And it is important that Wordsworth describes two spots of time, the later being his vigil on a crag watching for horses to carry him home, where ten days later his father died. There are similarities between the two episodes—the physical circumstances are lonely and desolate, death shadows each event, and so forth— but some contrasts are notable. The girl with the pitcher suddenly appears before the boy's eyes; on the crag he watches for hours "straining" his "eyes intensely"—in vain. In fact, the sight which he desired so fervently is not reported.

The impressiveness of the second incident, moreover, lies in its contiguity to what followed, his father's death, whereas the first is independently memorable. The role of each incident differs, too. The first is associated with a place around which Wordsworth later "roam'd," touching it with a "radiance more divine" from the "golden gleam" of youth, which could fall on the spot because of the poet's antecedent experience there. The second incident, whose recollection conveys a chastisement beyond the "trite reflections of morality," does not involve actual return to the physical location. Rather the poet returns mnemonically to "drink as at a fountain." From the second spot he *receives* nourishment; upon the first he *bestows* radiance. That the second incident actually occurred later than the first is less important than that the second is more mentalized, less directly and extensively determined by physical action and particularized location. The order of the incidents illustrates Wordsworth's assertion in the passage interpolated between them: "That from thyself it is that thou must give,/ Else never can receive."

Sight dominates the first spot of time. In introducing the incident Wordsworth says that "memory can look back," and he carries

through this orientation in all details—the letters of the "monumen-
tal writing," for example, are "fresh and visible." The essential
nouns and verbs reiterate the predominantly visual quality of the
scene: "espy," "saw," "sight," "look'd." The second incident is
richer. The boy "watch'd" from a crag which "overlook'd" the
two roads, "straining" his eyes, yet there is no visual equivalent of
the pictorialized girl with a pitcher, only the mist advancing in "in-
disputable shapes," the picture of these two words itself defeating
simple visualization. Other sensations and more complex associa-
tions appear. There is the personification of the "whistling haw-
thorn" and "naked wall"; the "day" is, so to speak, textured,
"stormy and rough and wild," this tactileness reinforced by "wind
and sleety rain" and enriched by "the noise of wood and water";
the synaesthesia of "bleak music" is supported by the Wordsworth-
ian verbal transfer of "the business of the elements." To this com-
plex of "spectacles and sounds" the poet can "repair" and "drink"
when "storm and rain/ Beat on my roof" or when, simply, "I am
in the woods," because the "workings" of his "spirit" are "brought"
to him. As giving leads to receiving, so visual sensation produces
mentalized, spiritualized, polymorphous sensory experience. "Out-
ward sense" is psychically transfigured. The movement from single
to multiple, limited to enriched sensation, both concretizes and
counterpoints the movement from giving to receiving. In the sec-
ond incident Wordsworth, though receptive, is more a participant.
In the first episode his vision is the result of inadvertent loss of his
guide; he "chanc'd to espy" the scene. In the second incident he
deliberately climbs the crag and remains for a long time in the van-
tage point: to a degree he determines the situation he experiences.
The simple autobiographical progression from spot to spot, and
their superficial unification through overt similarities, conceals a
more intricate, dynamic, and meaningful patterning: how the visual
is transformed into the visionary.

The Haywain's simplicity, too, conceals richness. The painter
cannot utilize the temporal sequentiality the poet exploits, but a
full response to the picture is not instantaneous. It is true that we
see the whole picture more quickly than we read all of Wordsworth's
130 lines. Yet as we continue to look at the picture we become
aware of something beyond the visual: there comes a consciousness
of tactile attributes, the texture of the rough wood of the wagon,

the water-eroded posts, the furred mossiness of the mill walls, the muckiness of the river bank, the mobility of the water, the fibrous strength of the plants, especially the trees. From this awareness of textures emerge, however faintly, imagined impressions of the smell of the water and the warm air and of the unobtrusive sounds which must be part of such a scene, the almost inaudible movement of the leaves, the sibilance of the water, the hum of invisible insects.

Possibly I am eccentrically impressionistic, but I find it difficult to explain the durable satisfaction of *The Haywain* without suggesting that its visual effect is so arranged that it evokes more subtle mental satisfactions deriving from my creation of polymorphous sensory imaginings.[20] And whether or not one accepts my conviction that the spots of time and *The Haywain* contain analogous patterns carrying us from superficial sight into a realm of diverse and interplaying imaginative sensations, it is clear the two artists employ similar modes of contrast. Most obvious is that between movement and quiescence, the halted wagon under clouds moving overhead, the boy seeing the girl with her wind-vexed garments against the silent immobility of pool, hill, and beacon. This contrast, of which the spot of time itself is an embodiment, being the moment of time which emerges out of the flow of time (as Constable's *Noon* is one particular noon), is sustained by subtler oppositions. The spots of time retain their temporality. They are narrative incidents, not epiphanies, and Wordsworth's memories of them follow historical sequence, undergoing modifications in time. This perhaps accounts for the reality which his personal reminiscences convey. We believe in Wordsworth's memories because he does not claim that they are unchanging; they, too, are vital.

Constable provides us with a static scene of the flow of natural processes; indeed, the stasis of the scene is impressive because it encompasses the power of that flow. The dog, for example, in the act of moving supplies a measure of motion different from that of

20. I am encouraged to subjective impressionism by many of Constable's own remarks calling attention to sensations other than sight aroused by a natural scene, as, for instance, his objection to landscape art which serves only "to blind our eyes and senses from seeing the sun shine, the feilds [*sic*] bloom, the trees blossom, & to hear the foliage rustle" (letter to Leslie, 13 February 1833, *Correspondence,* ed. Beckett, 3: 94). In this respect it is interesting to compare Constable's comments on nature with Delacroix's, for the English artist more frequently refers to sensations other than visual as well as to processes of growth and change, "the feilds bloom, the trees blossom."

the stream, the men with the wagon, the shifting clouds in the sky. Another movement in stasis is captured by the shapes of the trees, the twisting of whose branches and the clustering of whose foliage record the complex processes not only of external forces such as wind but also of inner growth. Picture and poem are alike and different because Wordsworth reveals the fixedness that exists within life's movement, and Constable reveals the movement that exists with life's fixedness. But the vision of life as a coherence of change and permanence, a coherence in which man has a place, is shared by painter and poet, who are perhaps constrained by the difference between their media to represent a similar vision diversely.

Painting is static; its "movements" must be represented by what does not itself move. Poetry moves; the effect of its words depends upon their relations in temporal sequence. Poetry is auditory, and the too rapid imposition of one sound upon another destroys the possibility of meaning. But such distinctions are largely arbitrary. I doubt that one sees two contrasting things in a picture simultaneously any more than one hears two contrasting sounds simultaneously. The "movement" of poetry is to a degree metaphoric. There is probably as much time between our perception of a red spot and a blue spot as between our perception of a noun and a verb. I raise these points because what I have said of stasis and motion suggests that Wordsworth and Constable are alike in straining, however unobtrusively, the limitations imposed by their respective media.

Wordsworth utilizes the movement of verse to evoke feeling for what endures even though changing, what does not of itself move, a mnemonic image. He takes advantage of poetry's fluidity and impalpability to represent how (and with what rewards) we create lasting images out of the perpetual streaming in of sensations. Constable utilizes the palpability of his medium to evoke feeling for the mobile transparence of natural life. Although the light spot in the background of *The Haywain* is caused by the reflection of sunlight off grass, the effect is of a brightness in the air. The luminosity of the invisible atmosphere, when our eye returns to the reflected sheen in front of the wain, stimulates our awareness of the brightness of the air we see through as we see into the painting. Our sense of this omnipresently impalpable medium, the breath of life, helps to evoke our feeling that all the distinct objects in the picture are invisibly united in a living activity more significant than their isolating outlines.

One recognizes an expansive rhythm in both poem and painting; beginning with immediate physical details, one progresses to an encompassing vision. The local and particular becomes a focus for thoughts and feelings which carry beyond the frame of the scene. The structure of Wordsworth's passage ensures that we are not confined to one moment. Constable's painting is organized so as to force our imagination beyond the limits of what is depicted. The edifice on the viewer's left is incomplete; the stream comes from the back of the picture and flows away (over eroded and half-submerged structures) to the right; the trees rise toward a clouded sky moving up and to the right out of the frame. In both passage and painting details are arranged so as to develop our sense not merely of the vast, surrounding dimensions of nature but also of their diversity. Both make us feel a rhythmic coherence between the singular-specific and multiplex-universal.

This coherence is in large measure due to an aesthetic diffusiveness. There are two spots of time, so we are encouraged to respond to a pattern of relation rather than to one event in itself. Constable's equivalent is the bright sunlight in the background beyond the trees, which attracts the eye as imperatively as the wagon and glinting water in the foreground. Another kind of diffusion is provided by the red on the horses' collars. He often uses this dark red, not common in natural objects, to focus attention on the human participants. By this mode of emphasis (in *The Haywain* echoed by the two tiny figures in the background which carry the human farther into nature) he is able to keep his figures small in relation to the landscape yet to assure their importance. And landscape size is important to both Wordsworth and Constable, who do justice to all three of the dimensions: neither height nor depth nor width is stressed at the expense of the others. Both painting and poetry, then, urge us beyond concentration on things in themselves, in their exclusiveness, and make us extend our vision from minute particulars to the less tangible, but no less real, dimensions of an inclusive unity.

The specific is not rejected; it is loved for itself. But the specific is connected to large rhythms: exhilaration as a response to Wordsworth's and Constable's trivial subjects derives from this expansive thrust. In the work of neither, despite their parallel limitedness of ostensible subject matter and the restricted locales in which each

felt at home, does one feel confinement or a claustral atmosphere.

For each, home is where he feels at home. What they love is what is familiar—to them. And they love it because it is familiar. Because they love it, their vitality expands and intensifies within its influence. The limited localities in which they flourish are their means for feeling at home on the earth. And their art makes us feel not that we would enjoy Cumberland or East Anglia but that *we* are at home on the earth.

They convey such comfort because they create a harmony between the rhythmic unity in scenes and incidents, physical patterns out there, and a correspondent rhythmic unity in the mind, psychic patterns in here. Wordsworth asserts that spots of time testify to the fact that "the mind is lord and master" and "outward sense" an "obedient servant." In part this means that the incidents are important because remembered. They are notable because they have become psychic places. But why should we be interested in his memories? What interests a reader of the "spots of time" passage is a principle which it reveals, making the reader aware of a potential power in himself. The nature of the power is indicated by the phrase "outward sense," implying corresponding inward sense. The passage depicts how sensations deriving from the external, physical world provide means by which the mind creates an inner world as real as the outer, and one which can affect the outer as surely as it affects the inner.

Neither outer nor inner world is superior; both are necessary, because each meaningfully exists only in relation to the other; without both there can be no working of spirit, which is an interchange of energy. What we learn in *The Prelude* passage is how the geographical locales where Wordsworth saw the girl and waited for the horses have become foci of this interaction. As such they are invisible to anyone else but they are real to the poet. Certain geographical localities have become identified for him as features of his temporal experience because past incidents have become places in his mind: a memory by definition is something located in the mind. In a literal fashion, then, Wordsworth's spots of time are life-enhancing.

Berenson's phrase is appropriate because *The Prelude* claims that the poet's power is enhanced by his creation of an image of his

imagination's growth. And an analogous enhancement is what Constable affords us in *The Haywain*. Its original title, *Landscape: Noon*, indicates that he portrays both a place and a time. And our pleasure in it comes not from its accurate representation of bucolic objects but rather from the power it arouses in us to relate the external scene to our inner life. What is involved is not merely empathy. Constable's painting reveals how physical things in themselves and in one of their infinite number of possible arrangements embody invisible processes and convey through the embodiment the rhythmic compatibility of mental, conscious, activities and physical, unconscious, activities. That is to say, the painting is structured to sensitize us to the pleasure of imaginative perception. It satisfies because it dramatizes emotionalized perception as a mutual interchange of the intangible and inner with the tangible and outer. We belong to the scene and it belongs to us. Although we have never before encountered this scene, we feel at home in it.[21]

Both *The Haywain* and the "spots of time" passage enable us to experience what Coleridge calls "the one Life that is within us and abroad," but Wordsworth works through the psychological to render the rhythmic interchange that is life, and Constable works through the physiological. The difference defines the difference in the artists' media. It is the similitude in their aims within the dissimilitude of their methods that matters, which enables one to define one aspect of their shared culture, their Romanticism.

Their Romanticism is obsolete. Every year since their time landscapes they loved have diminished. Their silence has been filled with noise. More people have crowded into what for them were sparsely populated vistas. There have been more subtle transformations, too. Most of us today do not desire the life represented in *The Haywain*. Few want to be farmers. We do not want to think the way Wordsworth thought, we do not now value his kind of memory.

One observes the paradox that their care for the simple, even the elemental, does not extend into our celebration of the primitive.

21. As Graham Reynolds points out in *Constable: The Natural Painter*, most of the mills on the Stour shown in Constable's pictures were, or had been, the property of his family, yet the pictures do not impress one as "private." There is nothing possessive in Constable's vision; if anything, he (like Wordsworth) is "possessed" by the place he loves.

They represent the rhythms and qualities basic to human existence from the Neolithic Age until the nineteenth century, from the establishment of the agricultural revolution to the emergence of industrialized civilization. The strength of their art lies in its refusal to follow the modern highroad away from living continuities into metaphysical primitivism, into the aesthetics of essences and archetypes and eternal forms. So the art of both must now seem quaint, even remote. Constable belonged to the one generation which could feel the urgency of loving an old wooden wagon simply because as an old wooden wagon it embodied recurrent modes of man's interactions with the processes of the natural world. Wordsworth belonged to the one generation in which one could delight in the song of a solitary reaper not as a nostalgic curiosity and not as a timeless symbol but simply as living expression of the rhythms by which mankind, not forever, but only for millennia, had shared his life in nature:

> Will no one tell me what she sings?
> Perhaps the plaintive numbers flow
> For old, unhappy, far-off things,
> And battles long ago:
> Or is it some more humble lay,
> Familiar matter of to-day?
> Some natural sorrow, loss, or pain,
> That has been, and may be again?

If my discussion of *The Haywain* and the "spots of time" passage in *The Prelude* has established comparabilities, they are especially interesting because the graphic and poetic traditions from which each emerges are distinct. One distinction is in what George Kubler calls "systematic age."[22] The tradition of landscape painting upon which Constable drew begins before the Renaissance. The tradition of descriptive poetry most relevant to Wordsworth's spots of time originates no earlier than the mid-seventeenth century. I shall suggest that landscape painting reached a peak in the mid-seventeenth century, beyond which it did not advance for nearly a century and a half, and that the later florescence was due in part to the effect of emerging landscape poetry. There is a historical reason why Wordsworth's art and Constable's art are comparable: their poems and pictures reflect *interaction* between the arts in the age preceding

22. George Kubler, *The Shape of Time* (New Haven, 1962).

theirs, an interaction which Wordsworth and Constable carry forward in original ways and to new purposes. Before turning to that history, I want to extend the comparisons I have already made. Without attempting to delineate the richness of either Wordsworth's or Constable's *oeuvre*, I hope to suggest—by treating Wordsworth's *Tintern Abbey* in relation to Constable's *The Cornfield*, and *Peele Castle* in relation to *Hadleigh Castle*—that analogies I have pointed out are not idiosyncrasies of specific works but represent persistent features in the artistry of each man.

2
Tintern Abbey and
The Cornfield

Both *Tintern Abbey* and *The Cornfield* depict specific places. Yet both make place embody time.[1] "Five years have past," Wordsworth begins, and throughout the poem he recurs to the passage of time. *The Cornfield* has impressed many commentators as representing a moment as well as a locality. Constable stresses diversity of temporal modes: the boy drinking, the dog turning its head, in the middle distance the plow set aside, the hunter walking, and in the background the square permanence of the church. Time in nature is represented by foreground trees, one old and broken, by the cornfield itself, and by clouds moving across the sky. Poem and painting are spots of time, because poet and painter concentrate on ecological actuality: living interrelations exist only in time.

1. When exhibited in Worcester in 1835 *The Cornfield* was described as *Harvest Noon: A Lane Scene* (C. R. Leslie, *Memoirs of the Life of John Constable*, ed. Jonathan Mayne [London, 1951], p. 246); the picture upon occasion was referred to as *Boy Drinking*. It poses several problems. William T. Whitley, *Art in England* (New York and Cambridge, 1930), p. 101, points out that the dimensions of the picture as it hangs in the National Gallery today are smaller than those listed when it was exhibited at the British institution in 1827, 4'8" X 4' as opposed to 5'10" X 5'3" originally. Thackeray, a perceptive admirer of Constable, thought the scene represented "the influence of a late shower," a remark which may be less puzzling if one considers that Constable's pictures have darkened significantly over the years.

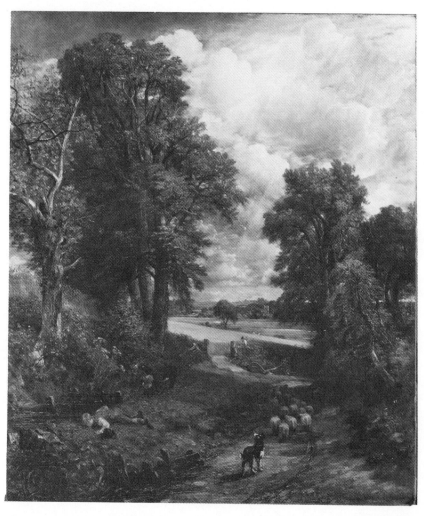

Constable, *The Cornfield*. (Reproduced by courtesy of the Trustees, the National Gallery, London.)

The primary relation dramatized in each work is that of man to nature. In *Tintern Abbey* the relation is intrinsically temporal. To Wordsworth, separating a "moment" of experience from the continuousness that is time is to lose the reality of the moment. To him time *is* continuity: his concept of spots of time implies noticeable areas in a larger, continuous fabric. Temporal interrelation of man and nature in *The Cornfield* is evoked not so much by a representation of men's acts (or the results of their acts) as by their rhythmic positionings within larger rhythms of natural existence. This is illustrated by the foreground-to-background line of humanity: the boy drinking at the pool, the huntsman in the middle distance (with only the upper half of his body visible), behind him the farm laborers almost hidden by the grain, and in the background the man-made edifice of worship rising in front of still more of nature's world. The diagonal progression from youth to the hope of life beyond death within the context of nature is almost too contrived, and critics have overlooked it only because Constable complicates and enriches its stark directionality.[2] Old structures built by men, the fence protruding into the path, the dams in the stream, even the path itself in the foreground, prepare the eye for the distant church, as does the plow in the middle distance. The very grain field which so abruptly cuts off the path is centered so as to focus our attention on its artificiality in contrast to the purely natural growth of the foreground trees and the far-distant wooded hills. The grain, an annual crop, is in every aspect, including that of time, the midpoint, the nexus, of man's relation to nature.

"Corn" is a crop, plants whose distribution and growth is controlled by man, just as the sheep in the foreground are domesticated animals. Crops and domestic animals are nature humanized. They embody the impress of human thought as surely as the boy at the stream embodies the primal fashion in which nature nourishes man. Constable presents these interdependencies as an interwoven fabric of temporalities: we see the boy's immediate satisfaction of his thirst in relation to the plow and ripening grain, the aged, storm-wracked tree in the foreground in relation to the differently weathered wood of the fallen gate—and so on. Interpenetration of diverse rhythmic continuities is the special unity of *The Cornfield.*

2. Some of the best studies of Constable's work are cited in chapter 1, notes 9 and 13, above.

As many commentators have observed, *Tintern Abbey*'s structure is that of spirals, or expansive-contrastive movements, in time.[3] Less noticed is Wordsworth's technique of superimposition. The poem's opening words, "Five years have past; . . . and *again* I hear," prepare us to respond to the poet's description as not merely of immediate impressions but also of their superimposition upon earlier impressions. What we see in *Tintern Abbey* is not a single sight. We see, instead, the sight of one time (a real prospect or an imagined one) laid over the sight of another time. At the conclusion of the poem, for example, the poet foresees his sister in the future envisioning in her mind's eye the "steep woods and lofty cliffs" of the Wye in relation to his sight of them at an earlier time, that is, *now*, the moment of composition.

Superimposition applies not alone to repeated perceptual experiences but also to different modes of visualization—actual perception, memory of perception, mental visualization, imagined mental visualization. The "humanization" of the Wye scene derives from the interplay of these various superimpositions. The interplay occurs because the scene is familiar to the poet. For a reader, any freshness in the poem comes through Wordsworth's rendering of what is to him not new, not merely momentary, not a unique sight. He does not remove the film of his familiarity, but, instead, makes us aware that a film of familiarity does in fact infold the objects of his verse. Wordsworth endeavoured to look "steadily" at his subject, as he says in the 1800 Preface, meaning that he observes how he observes. He tells us not so much what an object is in itself as what it is in his perception of it, in short, what it means to him.[4]

His poetry teaches us not to see things in a new way but to enjoy our customary way of seeing familiar sights. *Tintern Abbey* is presented to us as a known scene, and the more we reread the poem—the better we know it—the closer we approach the poet's position. The

3. Among the many analyses of the poem, three of the most impressive, each of which deals with repetitions in the poem and its expansive-contractive movement, are Albert S. Gérard, *English Romantic Poetry* (Berkeley and Los Angeles, 1968), pp. 89–117, Roger N. Murray, *Wordsworth's Style* (Lincoln, Neb., 1967), pp. 25–32, and Colin C. Clark, *Romantic Paradox* (London, 1962), pp. 39–53.

4. Frederick A. Pottle's essay "The Eye and the Object in the Poetry of Wordsworth" (focused on *I Wandered Lonely As A Cloud*), in *Wordsworth Centenary Studies*, ed. G. T. Dunklin (Princeton, 1951), pp. 23–42, remains one of the most cogent and illuminating discussions of perception in Wordsworth's poetry.

poem's lack of rhetorical flashiness enhances its capacity to be absorbed slowly into the reader's experience. Gradually we come to appreciate the familiarity which the poet celebrates as a mode of significant experience. Wordsworth's slow, prosaic manner, his avoidance of climax and surprise, aids the reader's sense of being conversant with his subject and thereby encourages his gradual recognition that the importance of the familiar lies in its manifestation of some rhythmic continuity necessary to our life.

To make the well-known significant is not easy. Pictures in our own home we seldom notice. Yet their presence affects us, as we realize when one is unexpectedly removed. In making us value the subliminal effects of the familiar an artist must avoid, through the mere fact of artistic representation, rendering the accepted as unusual. He is restricted to conveying no more than what Wordsworth calls "a gentle shock of mild surprise." One solution is to present as familiar what in fact is not—as Wordsworth does with a moment of intense personal experience recorded in *Tintern Abbey*. The scenes depicted in Constable's best paintings are, somewhat analogously, perhaps not so commonplace as they first appear—even 150 years ago a white horse in a boat was no common sight. In *The Cornfield*, more subtly, the figure of the boy drinking, although characteristically posed is not archetypical; his body's awkwardness, the strain of his muscles, prevents us from responding to his posture, as we do to similar figures in, say, Breughel, as typical. Even more interesting are Constable's trees, which are remarkably individualized. Constable's compositionally significant trees are unique, and, if one stops to consider, do not so much remind us of other trees as impress us with their individuality. This characteristic can be illustrated by contrasting Constable's trees with those of Gainsborough, and even Rubens, both of whom influenced him. The earlier artists tend to perceive trees as *like* elements of woods. Contrarily, Constable seldom paints woods except as subordinate parts of a landscape. Often he literally could not see a forest for the trees.

His treatment of trees and figures is part of what I call his "demythologizing" of landscape. Although influenced by Claude, who, like Poussin, painted mythological landscapes (as did Constable's great contemporary, Turner), Constable owed more to the example of Flemish, Dutch, and English realistic painters. Yet he goes

beyond the realists in virtually eliminating conventionalized iconography. There are plenty of both English and Dutch pictures of rural scenes including much the same visual material as we find in *The Cornfield*, but Constable deemphasizes the usual significance of these objects—without reducing the objects to mere peculiarity. This is why his paintings seem both familiar and unique. He paints scenes in which he individualizes, renders in its uniqueness an apparently conventionalized compositional structure and each element within the composition. He accomplishes this by substituting an organization of imaginative correspondences for the rational or conceptualized arrangements of earlier practitioners in the rural landscape genre. It is difficult, for example, to say what *The Cornfield* is a picture of. In part the difficulty arises from Constable's diffusion of focus: no one element dominates others. The boy drinking and the bright cornfield are equal but unalike foci of visual attention, making up what might be termed "compositional texture." "Texture" implies roughness or irregularity of surface, and Constable is adept at depicting the literal texture of objects. But he "texturizes" the composition of his painting as a whole, structuring it around an interplay of relations between incongruous elements— incongruous both in the sense that there is no volumetric similarity between a boy and a cornfield, and also in the sense that there is no obvious referential or symbolic connection between the boy drinking in the shaded left foreground and the sunny grainfield centered in the middle distance. As I have pointed out, boy and field are indeed connected, but that deeper unity is significant because each is oblivious of the other, because superficially they seem not related. The unity of a textured surface, a fur rug for example, differs from the unity of a smooth surface in that the rug's unity underlies superficial differentiations.

 Tintern Abbey is likewise compositionally textured. As with *The Cornfield*, it is difficult to define what the poem is about, even though evidence of its careful contriving is provided by a falsification (rather like the relocated church in the painting): from the poem alone one could not guess that Wordsworth's sister was less than two years younger than the poet.[5] Yet, as applied to poetry, "com-

5. The story of the Duke of Argyle hearing the poet recite *Tintern Abbey* many years after its composition, being impressed by the fervency of the poet's reading, and then being even more impressed when he realized the paralytic woman with Wordsworth was his

positional texture" is a metaphoric phrase, because there cannot be in a poem the literal texture a painter can represent. Time in poetry is the nearest analogue of literal texture in painting: linguistic inter-weaving is created by in-and-out movements of different time refer-ences. Like *The Cornfield, Tintern Abbey*'s structure is non-tecton-ic, its correspondences being imaginative rather than conceptual. The imaginative structuring is signalled by the poem's emotionality. Feelings hold the poem together, connecting different times. One reason is that, as contrasted to thoughts, emotions are time-bound; they are persistent rather than instantaneous phenomena; their strength increases and diminishes in an organic fashion, as the strength of ideas, which can hardly be said to possess duration, cannot. Emo-tion, furthermore, is tied to sensation, whereas thought, although it may ultimately derive from sensation, is almost by definition sensa-tion's antithesis.

Wordsworth treats emotion as the psychic manipulation of sensa-tion, the process by which psychic activity, inner impulse, mingles and coordinates with physical sensation, the reception of stimuli from outside. Wordsworth prefers the word "feeling" to "emotion," in part because he wants to exploit the dual relevance of "feeling," which by its ambiguity emphasizes the inseparableness of emotion and sensation. *Tintern Abbey* portrays a temporal shift in the mix-ture of emotion and sensation that is feeling, a shift toward in-creased potency of the psychic component. In his youth, sensation was "all in all" to the poet. "The sounding cataract/ Haunted" him "like a passion," and "colours" and "forms" were "An appetite; a feeling and a love." Then emotion *was* sensation. As a youth Words-worth spoke "the language of the sense" without recognizing it to be a language. That time of "aching joys" and "dizzy raptures" is past, but the poet finds "abundant recompense" for the loss of "thoughtless youth" in recognition that there *is* a "language of the

sister, grimly dramatizes the poet's falsification of Dorothy's age. It also proves, as John Danby points out, that the poem is not facilely optimistic, that Wordsworth could con-tinue to recite it with conviction because: "Wordsworth had had the most Nature could give, and the most, therefore, it could take away. He includes the record of the high experience . . . but is aware of the inevitability of loss" (*The Simple Wordsworth* [Lon-don, 1960], p. 96). The story of the recitation to the Duke will be found in *The Poetical Words of William Wordsworth,* 5 vols., ed. Ernest De Selincourt, 2nd ed. (Oxford, 1952), 2:517. All my quotations from Wordsworth's poetry are cited from this edition or the companion De Selincourt *Prelude.*

sense," the recognition making it possible for man to "create" as well as "perceive," to *shape* sensation with emotion, to render "feeling" more emotional and less "sensational." The progress of the poem is *from* a "thoughtless" coherence of feeling derived from sensation *toward* consciousness of the value of "healing thoughts/ Of tender joy," *from* a condition in which the efficacy of "feeling" is "unremembered" *to* a realization that memory can be a *source* for the revival of the vanished, simpler efficacy. The moment sanctified by *Tintern Abbey* is that in which the poet passes from merely loving nature to awareness of loving nature.[6]

This is why the poem is so repetitive. Just as the scene is repeated, so phrases, words, even sounds are reiterated to a degree that distinguishes Wordsworth's landscape poetry from that of his predecessors: "repetition and apparent tautology," he observed, "are frequently beauties of the highest kind." Sustained repetition, symptomatic of how important interweaving is to the poem, is testimony to how far Wordsworth has moved from the rationalized, conceptualized structuring which had dominated earlier nature poetry and in which repetition could be little more than redundancy. Less obvious but as important is the presentation of the speaker of the poem, the poet himself. Curiously, it is repetition which identifies the speaker as a unique individual. Others have observed the Wye valley, but no one else has seen the scene twice at the exact interval of five years. It is the peculiar *duplication* of experience which guarantees its uniqueness. Analogously, the poet is individualized by his sister. Many poets have sisters, but the special qualities Wordsworth attributes to his sister authenticate his uniqueness: nobody else has a sister quite like Dorothy. This individulization-through-duplication is necessary because sociologically the poet is not particularized. From the poem we learn nothing about the poet's class, occupations, position, or ambitions in the world. Except for the evidence of the verse itself we do not even know that

6. The implication of lines 73–74 is that in earliest youth pleasure comes less from sensations impinging from the external world than from the child's own "animal movements." The young child is primarily self-delighting. The *Intimations Ode* does not, as is sometimes suggested, reverse this psychology. In the *Ode* Wordsworth asserts that the inevitable loss of sensory sensitivity can be compensated for by development of psychically generated emotional power—"thoughts that do often lie too deep for tears." Age returns to a condition analogous to that of early childhood, when delight was self-created, though then unconsciously.

the speaker is a poet. Here is a deviation from a principal tradition of landscape poetry from which Wordsworth drew, one of the functions of which was to define the nature, character, and moral-sociological role of the sensitive man capable of poetic experience in nature. In *Tintern Abbey* the poet is simply "a man speaking to men."

The poem, moreover, is not addressed to an audience particularized as to class, culture, or taste; in its very self-centeredness it is "for all and concerning all." In *Tintern Abbey* Wordsworth employs no mask; he speaks to us, to all, simply as a man, out of his unique experience. A mask, a persona, even a point of view is a means of limiting such uniqueness. A point of view can be shared. A persona is a role that others can play. A mask is representative—one thing a mask cannot do is reveal individual expression. Wordsworth tries to speak to all men by being himself, uncircumscribed by any categorization. Few modern readers share his faith that by eliminating roles, by merely being himself, a poet can speak directly to everyone. But Constable, I think, did share it. *The Cornfield* does not reveal meaning through a limiting sociological perspective—which is why it is difficult to classify.[7] It is not quaint nor picturesque, not anti-industrial nor, in the usual sense of the term, assertively realistic. And it does not aim to be mythic.

Nor does *Tintern Abbey* establish a superpersonal pattern of perpetual reenactment, the pattern by which myth transcends time. The poem's significance lies, instead, in revealing a principle of life-development within the poet's particular experience: that life includes change, loss, and death. In the context of the poem's final lines, a meaning of the phrase to be "laid asleep/ In body" to "become a living soul" is that we truly live not by turning from the facts of natural being (including change and finally death) but by welcoming them. The bodily sleep of the early lines later becomes the envisaged death of the poet. The price, yet also the reward, of

7. That Constable was aware of the problems posed by his originality is shown by his prospectus to *English Landscape* (a collection of engravings of his work), in which he contrasts the "imitative or eclectic" mode with his own: "The results of the one mode, as they repeat that with which the eye is already familiar, are soon recognized and estimated, while the advances of the artist in a new path must necessarily be slow, for few are able to judge of that which deviates from the usual course, . . ." (quoted by Leslie, *Memoirs of Constable,* ed. Mayne, p. 179). For a fine sampling of Constable's opinions on art, and expressions of his preferences, such as that for water-eroded posts, see Leslie's selection, pp. 271–82.

consciousness, life fully individuated, is loss of the simpler immortality of more primitive (and "sleepless") life forms. Only through such acceptance, recognition that healthy awareness above all else is *of* change and finally death, can man truly experience the joy of life, attain complete participation in its continuity.[8]

This view (along with the poet's rejection of role) enables him to speak for the inarticulate, to be an artist of the inartistic. In *Tintern Abbey* by speaking of himself simply *as* himself Wordsworth expresses what he tries to dramatize more objectively in *Guilt and Sorrow, The Old Cumberland Beggar, The Ruined Cottage,* and *The Idiot Boy.* These poems of the 1790s are about what in the 1970s is called the "silent majority," the classes and characters which are and have been rarely the subjects of serious, nonpolemical art—the aesthetically as well as sociologically invisible.[9] Wordsworth's deepest interest in these people is not in their condition as victims of social oppression but in their voicelessness. He does not represent them as exemplars of injustice and, though mute, not as inglorious Miltons. He finds in their unspectacular, even routine, lives no mythic patterns, only the poetry of commonplace uninterestingness. He usually avoids the drastically impoverished or victimized, for such figures tend to be interesting, and their stories tend to fall into patterns suggestive of archetypal configurations. The strength of *Tintern Abbey* rests in part on Wordsworth's capacity to speak of himself in an analogously "uninteresting" fashion, just as a man, not even as a poet.

The strength of *The Cornfield* likewise springs out of its independence from both the conventional significancies that rural landscape pictures evoke and any appeal to supermundane possibilities. Constable's human figures are not, as I have said, typical, but neither is their individuality stressed so that it becomes a center of interest.

8. I do not dismiss the "mystical" aspects of *Tintern Abbey*, most notably expressed in lines 41–48 and 93–102, which have been much interpreted. But it seems to me that much of the interpretive debate is off the mark because founded on the presupposition that the supernatural and the natural are necessarily contradictory, thus reducing the supernatural, as Constable objected, to little more than the unnatural. This presupposition is explicitly affirmed by F. W. Bateson, *Wordsworth: A Re-interpretation* (London, 1954), p. 141. A judicious corrective to such oversimplifications is provided by M. H. Abrams, *Natural Supernaturalism* (Ithaca, 1970).

9. Jonathan Wordsworth, *The Music of Humanity* (New York and Evanston, 1969), argues that the pantheistic humanism characteristic of the earlier works tends to disappear after 1798.

The figures are, so to speak, individually anonymous, neither exploiters nor victims, not irrelevant additions to a natural scene but not dominating powers either. One can say that what is most interesting about *The Cornfield* as a whole is its uninterestingness. Constable's skill lies in painting in a fashion which does not impress us as peculiarly skillful. In fact, however, this quality unobtrusively encourages us to see *into*. Embodied in the scene, as in *Tintern Abbey,* is a principle of life-development. We see not merely a scene and objects but also man's relation to nature in time. We see something intangible uniting separate entities. We are taught by looking how to look beneath the surface of things without ignoring surfaces. Contemplation of the picture modifies our mode of perceiving it.

How Constable attains this result I find difficult to explain, in part because of inadequacies in critical terminology. There is, for example, little vocabulary by which to define the function of his figures. What I have called their anonymity is not that of a representative figure, a class, an occupation, or even the species man. It is an anonymity which does not deny individuality, as in some primitive people's taboo against the use of a personal name, the taboo serving to protect, rather than to diminish, the integrity of the individual. One can, however, point to Constable's consistent emphasis upon the textured aspect of his subject matter, the bark of trees, the clothing of humans, the weathering of artefacts, and, in general, the richness of depth of any surface—this characteristic being most overt, perhaps, in the grain field itself. Not only does the tall grain present a surface pattern with a depth dimension, but its central placement, so that it cannot be disconnected from what is in front, behind, or above it, principally establishes what I have called the textured composition of the whole painting.

Emphasis on texture contributes to the illusion of the painter's unskillfulness by suggesting blurriness (what immediately impresses one about a painting filled with precise, sharp detail, a Van Eyck or a pre-Raphaelite painting, say, is the painter's skill). The strained awkwardness of the boy's position, though in fact naturalistically appropriate (he is not in an easy position for drinking), adds to the illusion of inartisticness, as in a different fashion does the odd placing of the irrigation ditch above the path.[10] Constable's

10. Painters with whom I have discussed *The Cornfield* have pointed out the remarkably

endeavor, it seems to me, is to create a sight that any man might see. He presents the scene not as a farmer, nor as a social critic, nor even as an artist of the picturesque might be *expected* to see it. And this lack of prestructuring coheres with his fondness (like Wordsworth's) for the undramatic and unclimactic.

One consequence of this technique is that as we continue to look at the picture we find connections, since these are not preestablished. The connections, as I have pointed out, are primarily temporal, appropriately for a familiar country scene. Urban myths about country people's vision may mislead us here. The countryman, as Wordsworth knew, does not see details of his familiar surroundings with peculiar sharpness, although he identifies some objects, plants, say, as a stranger would not, and he can judge the significance of certain phenomena, indicators of weather change, for example. But the countryman sees details, as the visitor from the city does not, in terms of the unity of the situation, the unity including his familiarity with the scene as a whole. The best illustration occurring to me is that of a well-known trail through the woods. As we retraverse such a path, we notice many details because we know the trail as a whole, that is, we know what was there previously. We notice the new snake hole in the bank because it was not there day before yesterday, the broken branch because it is still held by a shred of bark, the spider because he has repaired his web. In short, our vision has a temporal dimension, which means that we are alert to change, we respond not just to things but also to their place in the rhythmic continuity of natural growth and decay. It is this vision toward which Constable's painting encourages us.

The hazards for a painter working toward this end are more acute

skillful arrangement of lines of force in the picture. One was especially impressed by the handling of the gate, which, he said, "moves in and out." Such comments highlight the equality of Constable's commitments to nature and artistic schema (to use Gombrich's term). Constable remarked of Richard Wilson, "One of the great men who shew to the world what exists in nature but which was not known till his time" (letter to Fisher, 9 May 1823, *Correspondence,* ed. Beckett, 6:117). And he quoted the painter Jackson as saying that "the whole object and difficulty of the art (indeed all arts) was '*to unite nature with imagination* . . .'" (letter of 4 July 1829, ibid., p. 249). Shields and Parris (see chapter 1, note 13) summarize brilliantly Constable's ambivalences (even anticipating my observation on his inability to see a forest for the trees in it), pointing out that as he grew older Constable painted less directly from observation of nature.

than for a poet. A painting is a single expression, and, therefore, it tends to falsify that continuousness constituting the vital rhythm which the painter wants to evoke. In addition, the painter strives to make visible that which is scarcely articulable: usually we cannot say why we love a particular place. Yet—and this in part explains Constable's appeal—quite consistently we are impelled to place our significant experiences. A confirmed urbanite is likely to remember even a fleeting love affair in terms of where it occurred. We need location because we live in time. *The Cornfield* satisfies because it affirms the importance of place as evidence of the intrinsic cohesiveness necessary to living. Life is continuity. And continuity implies connectedness. Biologically, fragmentation is synonymous with death. To appreciate *The Cornfield*, then, we must contemplate it for some time, because it is the temporal continuity and connectedness of life which the picture, of necessity, must reveal gradually.

The Cornfield thus parallels *Tintern Abbey*, in which we are led to recognize the processes by which our feelings change in the course of time. To recognize how we perceive is to become aware that our modes of perception alter, are, in fact, vital. So neither poem nor painting provides sharpness of definition; both avoid decisive clarity of surfaces. Both are textured in order to encourage *development* of response, the development consisting not in perception of profounder significance in what is represented, but, instead, an increasing awareness of how we may respond vitally to a world which is, above all else, ecologically unified. For, finally, both Wordsworth and Constable love nature, and it seems to me that the painter shares the poet's faith "that Nature never did betray/ The heart that loved her."[11] While man is in some respects distinct from nature, the distinction making possible his love for her, man is also a part of nature. One reason nature does not betray is that to do so would be to become self-contradictory. Wordsworth and Constable find satisfaction and security in the regularity

11. Richard J. Onorato, *The Character of the Poet* (Princeton, 1971), makes much of the phrase "never did betray" in a psychoanalytic interpretation (see especially pp. 37–45). His thesis, crudely, is that "betray" betrays the poet's unconscious feeling of having been betrayed. Though cogent, the argument seems finally not to recognize how self-consciously Wordsworth confronted the implications of his love for nature.

of natural life: the peace and serenity they find in nature depends on the unfailing lawfulness of her vitality.

But does not nature betray that part of man which is distinct from her? For Wordsworth, nature is no deceiver. He does not claim that nature is always sweet and kind and pleasant. He asserts only that she never "did betray" the heart that "loved" her. No woman ever left a man she truly loved because he hit her, and no man ever left a woman he truly loved because she acted like a bitch. Wordsworth loved nature, and he was not to be shaken by rough treatment. He loved her in full awareness (explicit in *Tintern Abbey*) that belonging to nature meant decay and death for him. Nature inexorably brings destruction, but she does not delude, mislead, or falsify—as men do. This faith illuminates Wordsworth's, and I think Constable's, demythologized presentations of man's relation to nature. The love they celebrate would be weakened by any appeal to the security of archetypal patternings. Myth is beyond nature. Any ritualization of experience would blur the clear-eyed commitment of these artists to the destiny of change their love for nature entails, and from which their deepest satisfactions arise.

Constable appears to share Wordsworth's view, though proof of this can never be absolute, because the testimony of painting is philosophically unexplicit. But Constable's well-documented pleasure in objects which dramatize the effect of nature's inexorable wearing away of particular things supports the comparison: "The sound of water escaping from mill dams, willows, old rotten planks, slimy posts, brickwork. I love such things." So does his fondness for light. Light in the natural world is forever moving, shifting, altering. It is the primal embodiment of natural mutability, the visible sign of earth's celestial movements. Of this transience Constable's art reminds us. It is the never-to-be-exactly-repeated patterns of brightness and darkness which give *The Cornfield* its enduring charm. "A good thing is never done twice," he said, adding, "The world is wide, no two days are alike, nor even two hours."

Nor, of course, two artists—which may justify one more poem-painting juxtaposition, even though the arts are less comparable than days or places. But art works may reveal parallelism in the careers of their creators, and this parallelism may serve to define the signif-

icance of differences between our aesthetic sensibility and that of Romantics, the last word suggesting a cultural contemporaneity inescapably (however unconsciously) crucial to both Constable's and Wordsworth's unique accomplishments.

3

Peele Castle and
Hadleigh Castle

Wordsworth's *Peele Castle* and Constable's *Hadleigh Castle* have been regarded as the artists' recantations of their earlier faith in and love for nature's beneficence. Picture and poem are sometimes interpreted as rejections of the joyousness of natural vitality and as aspirations toward more enduring, transcendent sources of hope. Assuredly both castles emblemize the artists' losses, recalling the death of Constable's wife and Wordsworth's brother. Assuredly, too, paintings of Constable's late years are more sombre in mood than his earlier works, and Wordsworth's later verse is both more stoical in tone and conventionally religious in theme than his earlier poetry. I suggest, however, that *Peele Castle* and *Hadleigh Castle* are less rejections than fulfillments of the art which preceded them.

The works are more conventional than the poems and paintings which distinguish the great decades of Wordsworth's and Constable's art, and of which *Hadleigh Castle* and *Peele Castle* mark the termination. It may be no accident that the picture was Constable's major exhibit in the spring of 1829, when he was finally elected to the Royal Academy. At this exhibition Constable imitated Turner by appending to his picture a quotation from Thomson's *Seasons. Hadleigh*

Castle is indebted not only to Thomson but also (though this apparently cannot be proved absolutely) to Wordsworth's *Peele Castle,* which was in turn inspired by a picture of Sir George Beaumont's. *Hadleigh Castle,* although commemorating Constable's wife, who died in 1828, can scarcely be without reference also to Beaumont, who had befriended both Wordsworth and Constable and who had died in 1827.[1]

On the other side, *Peele Castle* is unusual in Wordsworth's canon in being a poem about a painting. It exploits some conventions of sublimity and is cast in an established form, the quatrain elegy. The poem, in fact, is concerned with artifice, particularly artificial images. The first line is addressed, presumably, to Beaumont's picture of the castle. Perhaps Wordsworth is addressing his own mental image of the castle, but, even if so, a substantial object is not before him, as the Wye valley is before him in *Tintern Abbey.* Throughout the poem there runs a pattern of subterraneous reference to the distance between a sight and its spectator. Like *Tintern Abbey, Peele Castle* begins with a superimposition, but the later poem presents a painted image imposed upon the poet's recollected sight. The artificiality so introduced reinforces the distancing indicated by the word "neighbour," which suggests that, although he lived near the castle, Wordsworth was separated from it. In *Tintern Abbey* the poet is within the scene, part of it, not its neighbour.

The difference between the two poems can be illuminated by a comparison of functions in some of their shared words. "Once" in the opening line of *Peele Castle* suggests "one time only"; in

1. As J. R. Watson (see chapter 1, note 9) has suggested, the nature of the relations between Constable and Wordsworth is not easy to evaluate. It would be rewarding to study their tributes to their common patron, Sir George Beaumont, giving special attention to Constable's *The Cenotaph* and Wordsworth's *Elegiac Musings in the Grounds of Coleorton Hall.* But it is difficult to estimate Wordsworth's possible influence upon Constable. As Watson points out, Constable's letters prove that he knew *Peele Castle,* but he may have been impressed by the poem only after painting *Hadleigh Castle.* It seems to me almost certain that he had seen one of Beaumont's pictures of Peele Castle, but I can find no documentary proof. Even Wordsworth's knowledge of the Beaumont painting is uncertain. Mary Moorman, *William Wordsworth* (Oxford, 1965), 2: 45, citing Beaumont's and the poet's correspondence, is sure that Wordsworth saw the picture for the first time in July of 1806. But the painting, a reproduction of which was used as a frontispiece to Wordsworth's *Miscellaneous Poems* of 1815, had been executed much earlier, and apparently Beaumont made several pictures of the same subject. Lines 41–48 of Wordsworth's poem take on added poignance if they imply earlier sights of Beaumont's depiction of the Peele Castle scene.

Tintern Abbey Wordsworth says, "Once again/ Do I behold these steep and lofty cliffs." In the later poem the same verb is used to define a separation: "Not for a moment could I now behold/ A smiling sea, and be what I have been." The "little while" Wordsworth prayed for in *Tintern Abbey* that he might "behold in thee what I was once" has vanished. He can no longer go back; he cannot now be what he has been. He is separated from his past. This is *the* crisis of Wordsworth's life. At this point his memory fails, not in the sense of being unable to recall but in the sense of being unable to restore. The fear he expresses in the spots of time passage that the "hiding places" of power will in time be closed to him is here realized. Very little of Wordsworth's poetry after *Peele Castle* is poetry of memory, as so much of his verse of the preceding years had been.

In *Peele Castle* two Wordsworths are elegized, John and the youthful William. Line 53, "Farewell, farewell, the heart that lives alone," is addressed not to the poet's brother but to himself. To live in memory is to live alone, as the death of someone we love makes us realize. And if some words in *Tintern Abbey* reappear in *Peele Castle,* the phrase "abundant recompense" does not. What remains is "fortitude and patient cheer"—and the ambiguities of artifice.

The sight which "is to be borne" is a painting, a human artefact, like the castle itself. What Wordsworth strives for in *Peele Castle* is faith in the power of artifice to create images which can be imposed upon experience so as to establish a surrogate for the process by which, before, memories and actual experience had interpenetrated. But Wordsworth is honest. The turn toward artifice leads to no more than the epitaphic clarity of "Not without hope we suffer and we mourn." Beaumont's ship is a sinking "hulk"; the castle is little more than a "Pile," a crumbling ruin. The poem is poignant because hope does not become assurance. The turn of the traditional elegy—"Weep no more . . . for Lycidas is not dead"—is reversed in *Peele Castle.* John and the youthful William are dead, not translated to some other sphere. There is no possibility of restoration in *Peele Castle,* in which consolation lies only in facing a bleak and stormy future.

This stoicism, however, does not simply contradict the joy celebrated in *Tintern Abbey.* In *Peele Castle* the beauty and pleasure of Wordsworth's earlier vision of the castle is not rejected, though

it is to be "pitied" because it was "blind" to other, profounder realities. The poet sees through the superficiality of his earlier vision but without bitterness. His tone supports his claim that he speaks "with mind serene" despite his feeling of "loss" which "will ne'er be old." In *Tintern Abbey* man's participation in the process of time is celebrated as evidence of man's vitality, yet his participation is simultaneously recognized as limiting his joy.[2] Wordsworth's fortitude in *Peele Castle* reaffirms his commitment to the value of being aware of the temporal mode of our existence.

Beaumont's painting is commendable because, like the "picture of the mind" which "revives again" in *Tintern Abbey,* it represents life, and represents life more truly than would the picture Wordsworth might have painted in his younger days. Beaumont's painting is more illusionary: its flat surface suggests, as Wordsworth's picture would not have, a depth not actually in the canvas. Wordsworth's picture would, in the "fond illusion" of his "heart" have portrayed the *surface* of the castle, illuminated by the "gleam/ The light that never was." Wordsworth's picture would have represented light reflecting off the face of things; Beaumont's painting, exploiting the illusionism of art, represents depths. Having seen into the depths, Wordsworth cannot regard the "smiling" surface of the sea as he once did, but he can now "love" seeing "the look" with which the castle, "cased in the unfeeling armor of old time" "braves" elemental fury. Line 51 suggests that time, which brings our losses, armors us against the sufferings of loss. The ruined castle is representative of the function and destiny of artifice. The castle endures but is not immortal; what we see in Beaumont's picture is the castle's guttedness. But in its ruin the castle testifies to a creative energy which originally shaped it. It, like the ruined cottage in *The Excursion,* is the physical relic of a vanished human dream. The dream, in which the young Wordsworth had been "housed," has crumbled into broken stonework, but whereas the glory of the dream distanced him from his "Kind," imprisoned him, one might say, as

2. The stoicism of *Peele Castle* is implicit in *Tintern Abbey* insofar as the poet's love for nature expressed therein is not dependent upon nature's pleasantness. An analysis different from mine but, I think, complementary is J. D. O'Hara's "Ambiguity and Assertion in Wordsworth's 'Elegiac Stanzas,'" *Philological Quarterly* 47 (1968): 69–82, one of the few studies which considers seriously the relation of the poem to Beaumont's picture.

Margaret imprisoned herself in her cottage, the wrecking of the castle liberates him, opens the way to community with his fellows, though it is community of sorrow and loss.

It is suffering and mourning, not joy, which binds men together, makes a man one of mankind. Beaumont's picture, it should be observed, is more emotional than the one Wordsworth would have painted. Itself unfeeling, Beaumont's castle acts as a repository of emotional power; the poet's painted castle could only have been a source of superficial pleasure. It is not the light that never was glancing off the aged castle, but Beaumont's darkened image of its walls broken open that enables Wordsworth to look *forward*. Because the past is wrecked, he can "hope." For what could there have been to look forward to when he first saw Peele Castle? For what he now hopes he does not say. Life remains mysterious. But whereas in *Tintern Abbey* the future is filled with the past, is seen as a time when one will look back, in *Peele Castle* the future acquires its own enigmatic integrity, becoming something more than a vantage point for retrospection. *Peele Castle* presents the future as a field of emotionalized experience into which, cased in the unfeeling armor of old time, conscious of what he has lost, a man moves toward a dark destiny illuminated only by recognition that in so advancing he shares in the emotional burden of mankind.

Hadleigh Castle is less sombre than Wordsworth's poem. Because Constable's oil study in the National Gallery has been displayed more than the finished painting, now in the Mellon Collection, the picture has a reputation for roughness and darkness of tone. Although there are similarities between the finished picture and the oil sketch. and with the original line drawing of the castle in 1814, the total effect of the completed painting has some of the serenity of *Peele Castle*'s opening stanzas. The sketch, as Shields and Parris say, is "a battle ground." In the final version, development of the right-hand slope leading from the castle to the sea allows for an elliptical patterning of a path around the castle. To the left a youth with his dog advances up the slope, while to the right a cowherd with his cattle moves down toward meeting of sea and land.

The rather obvious symbolism is mitigated by the stark heaviness of the castle itself, which, to an unusual degree for Constable, dominates the composition. In the finished painting of *Hadleigh Castle* Constable has narrowed the two apertures which in the sketch admit

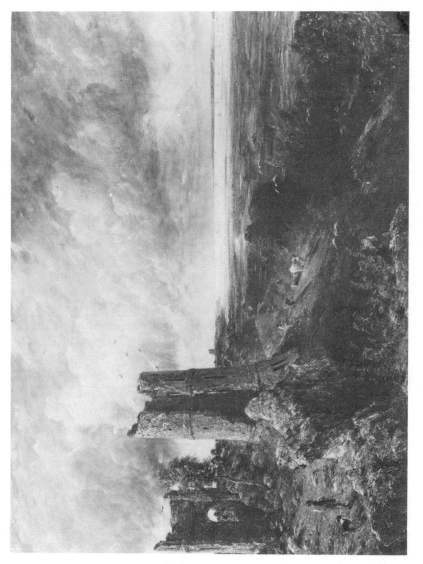

Constable, *Hadleigh Castle* (final version). (From the Collection of Mr. and Mrs. Paul Mellon.)

light into the castle shell. We see into an enclosed but roofless
tower, composed of virtually opaque walls except for the break
(facing us) running the full height of the tower. The inner form of
the tower reiterates the form of the promontory as seen through
the opening in the second fragment of castle to the left and as de-
fined by the sea to the right. The landscape conveys a sense of ex-
pansiveness, yet the elliptical designs swinging back toward the
viewer evoke, as does the tower itself, a feeling of closure. The
dark circularity contrasts with the bright upsurge of the clouds and
the scattered brilliance of the light gleaming through them and glint-
ing off the sea. None of Constable's earlier pictures exploit this
contrast so dramatically, because never before had Constable so di-
rectly represented the elemental destructiveness of time.

In *Hadleigh Castle* Constable's "chiaroscuro" comes close to con-
ventional chiaroscuro: one is aware of darkness in *conflict* with
light. Though light-dark interplay is always integral to Constable's
art, in *Hadleigh Castle* shadow becomes a positive force: the inside
of the tower is a reservoir of darkness and the entire promontory
is permeated by a shadowed bleakness. Harsh as is the rockiness of
the unfecund coastal ridge, more troubling are the birds, uniquely
prominent in this painting. There are two main groupings (rein-
forcing the strong repetitive patterning in this picture, e.g., the dis-
tant castle behind Hadleigh), those circling behind the tower and
those flying in from the sea toward the viewer. The flying scaven-
gers are disturbing to anyone familiar with Constable's earlier work.
Their transience in contrast to the endurance of the tower is not so
surprising; Constable frequently represents different temporal mo-
dalities, though seldom of such drastic contrast as this between an-
cient ruins of stone and birds in flight. The gulls convey an unusual
(for Constable) sense of height for the viewer. Constable prefers,
in general, low-level views so that he can present a richly textured,
earthy foreground. Usually heights, cliffs and the like, are relatively
distant elements in his pictures. In *Hadleigh Castle,* however, the
gull in the extreme foreground accentuates the precipitous slopes
in front of the viewer. We see across something like a chasm. Then,
too, the birds wing through light and shadow, appearing dark against
the bright clouds and bright against the dark shore growth and
rocks. The gulls are creatures of two worlds; their duality is rein-
forced by the castle, which, unlike the mills on the Stour, does not

fit into the landscape. Its broken verticality stands out, stark, against the rough irregularities of its surroundings. Here, as in *Peele Castle*, man's life and nature's do not readily and joyously cohere. There are, however, connections. The eroded wall that leads our eye toward the rent in the dark tower suggests the grim link between man's artifice and the natural world, for the stones hewn from the earth to build the castle are crumbling back into the lichen-covered irregularity from which, long ago, they were shaped.

Yet darkness, literal and metaphorical, does not obliterate the light that gleams, gray but brilliant, out of the storm clouds, touching sea, castle, the tower's edges, and the birds' wings with a brightness. The verses from Thomson's *Summer* which Constable appended to his painting when it was first exhibited are aptly illustrated.[3] The lines are taken from a passage in praise of light, and Constable's ultimate success in *Hadleigh Castle*, like Wordsworth's in *Peele Castle*, is to give depth and sombreness to his earlier vision of light's joy, without rejecting love for the temporal processes that are life.

In this poem and painting, more than in their predecessors, there is emphasis upon how we see, a presenting of landscape as the natural world in the act of being seen. The emphasis may be more dramatic in *Peele Castle*, in which there is no substantial nature, only images of it, but in *Hadleigh Castle* the precipitous slope in front of the viewer as well as the mingled light effects, the irregular beams through the clouds and the broken reflections off land and sea, and even the vista through the broken arch at the left, draw attention toward an act of vision. It is not surprising, then, that poem and

3. The lines printed by Constable in the catalogue of the exhibition are lines 165–70 of *Summer:*

> The desert joys
> Wildly, through all his melancholy bounds,
> Rude ruins glitter, and the briny deep,
> Seen from some pointed promontory's top
> Far to the blue horizon's utmost verge,
> Restless reflects a floating gleam.

The Complete Poetical Works of James Thomson, ed. J. Logie Robertson, (London and New York, 1908; reprinted 1951), p. 59. In the catalogue the punctuation of the lines differs slightly from Robertson's more accurate text. (Turner, incidentally, misquoted the same lines even more significantly when he appended them to *Dunstanburgh Castle,* exhibited in 1798. Constable was no doubt impressed not only by the lines he quotes but also by the entire passage which they conclude, a panegyric to light as the source of earthly life.

painting may seem more overtly artistic than earlier works. But
the art of Constable and Wordsworth alike had from its inception
been founded on concern with the perceptual act, and each in theo-
rizing was persistently drawn to defend his mode of portraying as
true to the fashion in which we see. *Hadleigh Castle* and *Peele
Castle* thus are developments, rather than reversals, of their creators'
earlier practices.

Poet and painter move toward a complicated realism. *Peele Castle*
speaks of the replacement of a pleasure principle by a reality prin-
ciple, but it is a painting which embodies the latter and a real scene
the former. The real scene of actual experience is presented, how-
ever, as an Elysian dream. And the poet concentrates not on the
titular structure itself but on the reflected image of the castle
"sleeping on a glassy sea," which "trembled" but "never passed
away." For most readers, the serene brightness of this vision *is* il-
luminated by a "light that never was"—"the Poet's dream." The
first twenty-eight lines of *Peele Castle* epitomize the calm beauty
of many of Wordsworth's earlier poems, embodied, for example, in
the opening lines of *Tintern Abbey.* Yet such scenes are never what
one would call "dreamy." Wordsworth never drops into a soft,
self-indulgent, merely sensually self-gratifying relation to nature.
And in *Peele Castle* Wordsworth's mode of experiencing has not
changed: his response to Beaumont's picture is equivalent to his re-
sponse to the Wye valley in *Tintern Abbey.* Both are emotional
rather than conceptual experiences, and both provoke understand-
ing not divorceable from specific feelings with little to do with ab-
stract knowledge.

Hadleigh Castle bears an analogous relation to earlier pictures
such as *The Cornfield,* which is realistically idyllic, vigorous rather
than dreamy, and not at all sweetly self-indulgent, even though its
loveliness is irradiated by consecrating light. Perhaps the water in
both Constable's painting and Wordsworth's poem points up the
parallel development. In *Hadleigh Castle* the sea is subordinate to
the promontory and plays a role like that of the canal water in the
Stour scenes. But because it is the sea, and a sea brilliantly if irreg-
ularly lighted, it possesses a symbolic power more intense than the
canals of the earlier paintings. In *Hadleigh Castle* we feel the sea to
be primordial matter, the fluid, ever-changing substratum of all
material life. The sheen off its distant surface compels us to think

of its depth, so much more violent and continuously self-transforming than the rocky headland. The shimmering foreground of *The Haywain* cannot call up such thoughts.

Wordsworth contrasts the "glassy surface" of "a sea that could not cease to smile" against "this sea in anger," with "trampling waves," for he elegizes a brother drowned. Yet the turbulent ocean he describes is a painted one, literally "pageantry of fear." When he praises the "passionate Work" and commends "the spirit that is here," "spirit" may refer both to the scene and its maker. We can respond to "this sea" as embodying the confrontation of man's spirit with the "deadly swell" of nature, with the flux and transformation that are essential to primordial matter. It is awareness of the substantive power of matter, and of the threat of the power, upon which *Peele Castle*'s elegiac inversion depends for its significance.

Neither here nor elsewhere does Wordsworth treat the fall from the paradise of early experience as fortunate. He never celebrates his loss of the bright joyousness, the tranquil vision, of early days. And in *Peele Castle* the "blindness" which permitted the poet his dream is so represented that we must respond to it affirmatively. Furthermore, Wordsworth actually saw the idyllic scene: the pleasure-principle existence of the poem was not unreal, delusory. He was not deceived by the situation itself. What he was blind to was the inevitability of the transformation of that scene, the inevitability of loss in time. What Wordsworth has learned is not that his Edenic vision was untrue and not that there is another place like it beyond this world, but that his vision had to vanish. For Wordsworth this knowledge (sensory and emotional rather than conceptual, tacit rather than explicit) is not alienating. The experience of his loss, instead, is powerful because it involves deeper penetration into and participation with life. This is why the first part of *Peele Castle* so distinguishes the scene from the poet perceiving it. As the idyllic vista Wordsworth would have painted has been transformed by Beaumont into a stormy scene, so the poet himself has changed. He now recognizes that just as the sun could not continue forever to smile nor the sea to remain calm, so he could not expect forever to remain youthfully joyous. Change is the law of life, both for nature and for man. Though the quality of their transformations may differ (a subject of the *Intimations Ode*), in *Peele Castle* he simply

affirms that man and nature are bound together because neither exists statically, because both are self-transforming powers.

For Wordsworth, alienation is the heart that lives alone, superficiality, self-indulgence in immediate sensory gratification, an egoism which in the Preface to the *Lyrical Ballads* he calls "savage torpor" requiring "gross and violent stimulants." The condition may result from prolonging a natural, appropriate egocentrism of youth into maturity. Because the adult is not a child, he can, and should, seek restorative recollections of his earlier experience. The finding out in this fashion of continuity between youth and maturity is not regressive in any pejorative sense, though it implies the courage to look back into one's earlier life. All of Wordsworth's poetry asserts the impossibility of a literal return to childish modes of existence. The pattern of *Peele Castle* is congruent with that of *We Are Seven:* the worlds of youth and adulthood are distinct, each valid in itself but distorting if imposed one upon the other. What is needed, as the poet says in *My Heart Leaps Up,* the key to the *Intimations Ode,* is a binding together of disparate conditions, a sense of the wholeness of life, which, because it is life, is perpetually changing. What Wordsworth seeks is the continuity of vital rhythm.

His best poetry discovers and delineates neither static permanence nor a transcendent mode of being but the inherent rhythms of the natural cosmos. By attuning himself to such rhythms man attains the richest fulfillment of which he is capable. Wordsworth is to us disturbing, but representative of his era, because he lacks interest in many subjects, techniques, and themes with which critics now assume poets must be concerned. In *Michael,* for example, Wordsworth gives relatively little attention to moral questions implied by the shepherd's experience, such as the corrupting influence of urban life upon his son, and even to the tragedy of Michael's shattered expectations, because he devotes so much care to evoking the rhythmic coherence of a simple man's entire life. Wordsworth's persisting aim is to define the rhythmic cohesiveness of living. *The Prelude,* to cite the obvious instance, is a search for an intrinsic rhythm in his own experience, an effort less to distinguish the meaning of what had happened to him than to elucidate what I call the underlying musicality of his existence, to attune his conscious awareness to the organic harmony of change, progression, diminishment, and endurance in time. *Tintern Abbey* attempts to find a recurrent melody of

process amidst the diverse tonalities of successive modes of being. *Peele Castle* deals with more profound rhythms, encompassing death and decay into the harmony of life. *Tintern Abbey* links "joy to joy." *Peele Castle* seeks to link joy to loss, to the mystery of separation. It is symptomatic of the latter poem's extension of the purposes of the former that the time span which provides basic structure, the lapse between "now" and "then," is ten years in *Peele Castle* and only five in *Tintern Abbey*.

One observes an analogous extension in *Hadleigh Castle*. I do not mean only that Constable returned to a sketch made fourteen years before, but also that in making the ruined castle the focus of his painting he presents a subject far more antique than those of many of his earlier large canvases. And he emphasizes this extended temporality by the dramatic flight of the birds past the ruin toward the viewer. This effort to encompass deeper rhythms can be observed in many of Constable's subsequent pictures—*Old Sarum, The Cenotaph,* and, most strikingly, in his reworkings in the mid-1830s of Stonehenge drawings from 1820: the stones are older and more decayed and counterpointed by a fleeting rainbow. *Hadleigh Castle,* like *Peele Castle,* deals directly with loss, destruction, and the death of things. The time-eroded artefacts, which in Constable's earlier paintings are subordinate elements, here become the center of attention, just as the dramatic opposition between the trembling loveliness of nature's surfaces and the implicitly dangerous power of her depths is now foregrounded.

Less obvious is Constable's movement toward overt artistry of manner. *Hadleigh Castle* not only has a fairly conventional subject but it is also plainly, even ostentatiously, a painting. Compare a photograph of it with one of, say, *Stoke-by-Nayland:* the latter could almost pass for an actual photograph, but the former is unmistakably a photograph of a painting. In Constable's later years he tended, especially through the use of "snow," fleckings of white paint, to stress the paintedness of his canvases. He thereby intensified the tactile quality which from the first had been one of his specialities as a landscapist.[4] In this increased texturing one may

4. Constable refers frequently to his efforts to attain effects of "dewiness" and "freshness" and to the hostility with which his efforts were greeted by the cognoscenti. An anecdote revealing of both Constable's quiet firmness and his contemporaries' lack of understanding is provided by Leslie (*Memoirs of Constable*, ed. Mayne, p. 177): "Chantrey

detect an analogue to the tensions between surface and depth, mo-
mentary and enduring, separation and unity I have pointed out in
Peele Castle.

Such tensions are appropriate in Constable's painting and Words-
worth's verse because both embody encounters, encounters between
a shaping imagination and natural actualities, between interior psy-
chic and exterior physical forces. They portray what scientists call
an interface, a situation in which different modes of being come in-
to contact and so can interact. A great interface is the surface of
the earth, where rock and water and atmosphere meet. A visible,
dramatic form of this meeting we call weather. Constable and
Wordsworth are among the first to make weather central to art.
Of course they had predecessors. One thinks of Ruisdael's looming
cloud masses as a model for Constable, and of Thomson's storms
and clearing scenes (as well as his fogs) as prototypes for Wordsworth's
fascination with atmospheric transformations. But the Romantics
are the first intensively to explore the conjunctions of inner with
outer weather. The storm in Beaumont's painting interacts with
the turbulence within the mind of the poet afflicted by his brother's
death. Constable's pious hopes in the wake of his wife's death inter-
act with the mingled shadow and brightness over Hadleigh Castle.
To these Romantics a fourth element in the interface of earth's sur-
face is the mind of man—in Teilhard de Chardin's terms, their inter-
face includes biosphere and noosphere.

That these artists conceive of the mind as literally interacting with
earth and water and air is less important than that they were pos-
sessed of psychological intuitions which permitted them to con-
ceive such interplay. They intuit the psyche to be like a landscape,
that is, constituted of dramatically differentiated elements, especial-
ly elements of light and dark, these being forerunners of what we to-
day call conscious and unconscious. The psyche for them is land-
scape-like in being a fluidly unhierarchic continuum and in deriving
its special character, or power, from processes of self-transformation.

told Constable its [*Hadleigh Castle*'s] foreground was too cold, and taking his palette
from him, he passed a strong glazing of asphaltum all over that part of the picture,
and while this was going on, Constable, who stood behind him in some degree of
alarm, said to me 'there goes all my dew.' He held in great respect Chantrey's judg-
ment in most matters, but this did not prevent his carefully taking from the picture
all that the great sculptor had done for it."

Like nature, which is ever-changing, perpetually growing and decay-
ing simultaneously, always active in accord with intrinsic and self-
energizing principles, the psyche consists in a diversity of phenom-
enal processes and is to be understood only in terms of principles
of metamorphosis and interpenetrations. This intuition of the na-
ture of the psyche opposes predominant Enlightenment views, such
as Locke's concept of the mind as the passive recipient of distinct
impressions, or Hartley's concept of mechanical association of dis-
crete vibrations. Enlightenment psychology is at root hierarchical,
assuming reason to be the mind's highest faculty, and is, therefore,
a psychology predominantly of what today we would call the con-
scious mind. Interest in reason and rationality intensified during
the seventeenth and eighteenth centuries, which also saw, however,
development of significant countermovements. For our purposes
an important symptom of the latter is the emergence of sublimity
as an aesthetic ideal. The preeminent characteristic of sublimity is
its transcendence of rules, of rationally explicable regulations for
the making and appreciation of art. The sublime transcends the
logical. Sublime art at least foreshadows a major transformation in
men's understanding of the nature of mind and a new tendency to
identify essential reality with fluid continuities rather than with
tectonic discriminations.

Sublimity also counteracts the tendency of reason to trivialize.
To explain is often to explain away, and rationality strives to re-
duce emotional charge. The intimate association of grandeur with
sublimity indicates the latter's celebration of the untrivial. Awe and
wonder and pleasurable fear, the emotions most consistently evoked
by sublimity—"indescribable feelings," as Mrs. Radcliffe so aptly
describes them—are linked to what is indeterminate, indefinite, ob-
scure, difficult to apprehend. These qualities are perhaps best
summed up by the term "infinite." What can be delimited, and
therefore controlled, explained by logical rule, is not sublime.

Wordsworth and Constable drew sustenance from the new aes-
thetic of sublimity but altered it. They were attracted by sublim-
ity's opposition to "trivializing." Their art repeatedly demonstrates
that nothing, however small or commonplace, is trivial. Their art
affirms the significance of the ordinary. What the enthusiast of the
sublime found in Alpine scenery, they detected in routine occur-
rences of commonplace living. If, as Whitehead has so persuasively

argued, Romanticism is a revolt in behalf of value, the revolt for
Wordsworth and Constable is in part an extension of sublime gran-
deur, an extension of awe, wonder, and fearful joy, into the realm
of unspectacular, even drab, existences.

Wordsworth and Constable also modified the sublime style's predi-
lection for indeterminacy. Their debt is apparent in their frequent
representations of clouds, mist, shadow, and forms lacking definitive
outline. The modification they worked is suggested by their con-
stancy, both in precept and practice, in rejecting indefiniteness as a
final aesthetic goal. The paradox here is explained by their "sci-
ence." What for the artist of the sublime was impressive because
indeterminate and beyond rational comprehension, for Romantic
artists is impressive because its superficial indeterminacy points
to intrinsic systems beyond definition by ordinary reason but capa-
ble of being imaginatively comprehended. For Constable, clouds
in their infinite mobility and variety embody, as more static objects
could not, the deeper lawfulness of the profound principles of natu-
ral vitality: "something far more deeply interfused."

That nature in its changeableness could be found so revealing de-
pends, however, on a hidden presupposition that the mind itself is
a temporally dynamic system, its apprehensive capabilities springing
from a perpetual interplay among its diversified components, which
do not adhere to any simple hierarchic ordering. Mind and nature,
percipient and perceived world fit, because the unity of both de-
pends equally upon rhythms organizing a ceaseless self-transforma-
tion and interpenetration of differentiated constituent elements.
Because our minds are interactivities of diverse powers, we only feel
at home in a mutable world composed of a multiplicity of phenom-
ena.

Recognition of this Romantic intuition suggests the inadequacy
of current answers to such questions as, Why were Romantic artists
so interested in nature?—or, more limitedly, Why were Constable
and Wordsworth so concerned with weather? I hypothesize that
Romantic artists had to be interested in the mutable intricacy of
natural phenomena because nothing else was adequate to embody
their conception of their minds. The nature poetry which flourished
from the mid-seventeenth onward is symptomatic no less of changes
in men's understanding of how their minds worked than of their un-
derstanding of how the external world worked.

An origin of these changes is found in the landscape painting of the seventeenth century, the period when, as Lord Clark has shown, landscape truly became art.[5] Wordsworth's stress on interdependence of mind and nature ultimately owes something to both realistic and classical painters (more than a century before his birth) who made the natural world a source of new artistic satisfactions. But of course he was more directly influenced by poets of the intervening century, who, more adventurously than painters of the time, explored interactions between the mind and nature. Wordsworth and other Romantics pursued these explorations to arrive at a position which finds both mind and nature realizing their full potential, each becoming totally vital in its own fashion, only when interacting. Since "other Romantics" include painters such as Constable, we must recognize that Romanticism may involve not only poets' debts to painters but also painters' debts to poets. The mutuality of indebtedness can perhaps best be focused by a study of localization—depiction of a specific real place as the core of a work of art.[6] The meaning of an

5. Kenneth Clark, *Landscape Into Art* (Boston, 1961), especially pp. 30–31, 49–53, 62–70.

6. One can speak of localization in Coleridgean terms of coalescence of subject and object. But here I wish to affirm the simple fact that Romantic art of unique experience is inseparable from representation of specific place. The old critics who spoke of Romantic local color were not off the mark. Some of the central issues of localization are discussed by M. H. Abrams in a valuable essay, "Structure and Style in the Greater Romantic Lyric," appearing first in *From Sensibility to Romanticism* and most recently in *Romanticism and Consciousness,* ed. Harold Bloom (New York, 1970), pp. 201–29. One point Abrams helps to elucidate is the fashion in which localized poetry encouraged poets to exploit certain functions of language slighted by their immediate predecessors. Wordsworth in a letter to Hamilton, 23 December 1829, suggests why the Romantics tended to subordinate what one might call the referential function of words in order to bring out their kinetic potency: "words are not a mere *vehicle,* but they are *powers* either to kill or to animate" (*Letters of William and Dorothy Wordsworth: The Later Years, 1821–1850,* ed. Ernest de Selincourt, 3 vols. [Oxford, 1939], 1: 437). Insofar as poets regard words as "powers" rather than vehicles, they are attracted to fluid verbal structuring, unformalized syntax, and unconventionalized rhetoric. Romantic painters, analogously, did not adapt colors to the schematizations of line but exploited colors' fluid relativism and interpenetrative qualities. It is no coincidence, then, that the rise of Romantic landscape art in England is inseparable from the development of a significant watercolor school. Albert O. Wlecke, *Wordsworth and the Sublime* (Berkeley and Los Angeles, 1973), connects the poet's determination "to make the humble sublime" (p. 108) with his conception of imagination as a power to perceive "phenomena . . . become intermingled, their presences interfusing with one another" (p. 109).

art of particular locales stands forth most clearly by being con-
trasted against earlier modes of landscape representation. After
developing this contrast in the immediately following chapters,
I shall try through another juxtaposition of specific poem and
specific painting to assess what in distinguishing one Romantic
work from another also links them and so defines, from our
point of view, the quality of the Romantic achievement.

4
Constable and
Graphic Landscape

Kenneth Clark's succinct history, *Landscape Into Art,* stylistically
as well as substantively complements John Ruskin's monumental
Modern Painters. There is little one needs to know about landscape
art that is not suggested by either the Victorian or the modern crit-
ic. It is true that Ruskin erred in implying that the Greeks and Ro-
mans were uninterested in landscape painting. Clark, supported by
another century of research, recognizes an extensive ancient tradi-
tion of graphic landscape, whose influence, carried on through
herbals and manuscript illuminations, was important in reviving land-
scape art at the beginning of the Renaissance.

Landscapes of antiquity were decorative, usually taking the form
of wall murals and often subserving architectural ends. Frequently
they substituted for windows, the pictured countryside occupying
a rectangular frame between pilasters. Some of the best surviving
examples are landscapes from the *Odyssey,* and the usual subjects
of ancient landscape appear to have been ideal, literary, imagined,
not realistic, not pictures of specific localities. The tone is general-
ly idyllic and dreamy. What is represented is a *locus amoenus.*

But these decorative pictures contain a good deal of naturalism.

Often a perforated rock appears, a common motif in landscape art, because it simultaneously dramatizes distance, provides visual depth, and stimulates imaginative awareness of what is not seen, what is blocked off by the stone. Because landscape does not have intrinsic limits, its own self-defining form, apperception is important to it. A landscape is part of the natural continuum, unlike an apple or a human figure, which are more easily defined as separate identities. The object depicted in landscape art is a coalescence of subject and object. This is one reason why landscape size is important. The landscapes of antiquity are ordinarily large, although many later landscapes are quite small. It is practicable to paint a picture of a man life size or larger, but a landscape painting can never be life size, can never be, in this respect, directly imitative. Ancient landscapes do not as a rule exploit the possibilities of this inherent miniaturization, just as they do not experiment with dimension relations, height to width, as do later landscapists (including Constable—compare *The Haywain* and *The Cornfield*). Finally, ancient landscapes do not represent clouds and lack chiaroscuro: they are bathed in a warm, even, serene light. Their atmosphere glows because unshadowed. In this respect, too, they are ideal, even though including accurately rendered natural phenomena.[1] The human figures represented are as a rule typical, not particularized—another function of idealization.

In considering this idealizing, we should remember that many of the pleasantest maps are of imaginary places. Some of the earliest, found in Egyptian tombs, are of the land of the dead. Surely there is no finer cartography than the endpapers of Stevenson's *Treasure Island,* which are appropriately precise: the sea is blue, the island is green, and the crosses blood red. The maker of an imaginary map— and all romancers and mythmakers are inspired cartographers—is like the landscape artist, who is not a dispenser of practical information but the creator of a meaningful microcosm out of the naturalistic clutter which surrounds us. His problem is to prevent accuracy from obscuring truth of representation, although his truth cannot be divorced from naturalistic accuracy.

1. The intrinsic complexity of landscape art appears even in the decorative landscapes of antiquity, illusory windows. The paintings, one might say, represent views of scenes rather than scenes. There is no antique story of someone trying to step into a painted landscape, no equivalent of the literal realism at issue in the story of Zeuxis and Apelles and birds pecking painted grapes.

Reference to the interplay of accuracy and truth haunts me, as it haunted Ruskin throughout *Modern Painters*. His defense of Turner is not, and could not be, that Turner turned away from ideal landscapes, but that Turner "idealized" his revolutionarily accurate observations of natural reality. To Ruskin, Turner is great because he saw nature as it is more clearly than anyone else, yet did not copy what he saw, but, instead, transformed his perceptions into creative visions.[2] Ruskin may have overvalued Turner, but he understood the main issue in any study of landscape representation.

It seems certain, for example, that disvaluation of naturalistic accuracy in part explains the disappearance of landscape art for nearly a millennium after the fall of Rome. As Lord Clark has observed, the classic tradition of landscape was preserved in manuscript illuminations, and re-emerged in the tiny, jewel-like "calendars" such as the *Hours of Turin*, in part at least painted by the Van Eycks, and the larger *Les tres riches heures du Duc de Berri*, primarily the work of the de Limbourgs. The retreat of classical landscape art into illuminations may be one of the happiest regressions in art history, for it may have led artists to an intuition of the significance of miniaturization.[3] The de Limbourgs and Van Eycks exemplified how an artist could *create*. In works so small of subjects so large imitation is so transformed in degree as to take on new meaning. In the "calendar" books we find an artificial microcosm containing objects, events, situations which before had seemed possible only in the macrocosm of divine creation. Because of the fantastically detailed accuracy of these little pictures of large natural scenes, they could revolutionize man's understanding of his relation to natural reality.[4]

Renaissance developments of the landscape art revived by artists such as the Van Eycks in the north and Lorenzetti in Italy climaxed in the second and third quarters of the seventeenth century,[5] with

2. Ruskin summed up his thesis in a letter of 8 August 1867: "You see every great man's work (his [Turner's] pre-eminently) is a *digestion* of nature, which makes glorious HUMAN FLESH of it. All my first work in "Modern Painters" was to show that one must have *nature* to *digest*—not chalk and water for milk" (*Letters of John Ruskin to Charles Eliot Norton*, 2 vols. [Boston and New York, 1905], 1: 168–69).

3. See Claude Lévy-Straus, *The Savage Mind* (Chicago, 1966), pp. 22 ff.

4. For qualifications of my hasty generalizations the reader should consult two magnificent works of scholarship, Erwin Panofsky, *Early Netherlandish Painting*, 2 vols. (Cambridge, Mass., 1958), especially 1: 140–44 on disguised symbolism, and Millard Meiss, *French Painting in the Time of Duc Jean de Berry,* 2 vols. (London, 1967).

5. Kenneth Clark traces these developments in *Landscape Into Art* (Boston, 1961). To

the work (to mention but a few of the most obvious examples) of Rubens (died 1640), Poussin (died 1665), Rembrandt (died 1669), Salomon Ruysdael (died 1670), Salvator Rosa (died 1673), Gaspard Poussin (died 1675), Jacob Ruisdael (died 1682), Claude Lorrain (died 1682), and Albert Cuyp (died 1691). This grouping becomes more impressive when one realizes that the next clustering of landscapists occurs only with the emergence of Romanticism in England. For more than a century landscape art was dominated by the achievements of the artists just listed (and the host of their less celebrated contemporaries), above all Poussin, Claude, and Rosa—although, because my concern is Constable I cannot disregard the work of northerners, especially the Dutch. A few comments on the landscapes of Rubens and Ruisdael may suggest the extent of Constable's indebtedness.

Rubens's special accomplishment lies in his rendering of the vitality of nature. He is the first landscapist whose pictures are filled with a sense of growth. His trees and shrubbery surge upward and outward to convey an impression of powerful inner forces. His perception of life as an interior force swelling out to fullness is inseparable from his representation of light as energy. For him, light is not merely illumination but physical power. If one compares Bellini with Rubens, for example, one notices that for the former light is a brightness highlighting edges, but for Rubens light is a penetrating force fusing as much as distinguishing. In a picture such as the *Chateau de Steen*, a late painting of documented influence on subsequent English landscapists, the principal source of aesthetic unity is light and color. The harmony of *Steen* is not statically formal but a fluid interaction of hues and tones. This picture also exemplifies Rubens's "widening" of landscape. The temporal richness of a landscape seems often to be a function of its

Clark's account I would add only a point or two associating graphic with literary history. As Max J. Friedländer has observed in *Landscape, Portrait, Still-Life*, translated by R. F. C. Hull (Oxford, 1949), p. 21, Van Eyck's distant views are diminutive near views. Suitably magnified, his backgrounds are identical with his foregrounds. That, of course, is not how we perceive. But Van Eyck is not interested in the subjective experience of perception; for him, truth is "out there." No one has surpassed him in discriminative accuracy; in his pictures every thing is distinct from every other thing. So even though foliage of background bushes is highly patterned, every leaf *seems* individualized (and, in fact, is individually painted). Van Eyck suppresses the interrelatedness of things, so his pictures appear static; there is no flow between elements. As I point out in the next chapter, an analogous descriptive technique is used by Chaucer.

width: like the *Chateau de Steen,* most of Constable's great Stour pictures are wider than they are high. The *Chateau de Steen* is particularly interesting in this respect, because Rubens arranges his composition so that our view from center foreground to left middle-distance is of a rich entanglement of diverse elements—the stump, low growth, and huntsman, then the horses, trees, and illuminated chateau facade. Our deepest view is into the right background across the middle-distance bridge. The triangular arrangement in which one corner is an open, almost empty, expansive vista links the immediate to the remote, diversified sensory richness of what is close and active to serene permanence of total setting. Constable attempted a variation upon this composition in *The Leaping Horse,* and Rubens's centered stump with confused low growth (the basis for the upright trees' vigorous rise) is a prototype for Constable's favored close foregrounds.

What Rubens does not present is subjective mood, even when he paints storms. Splendid and vivacious as his landscapes are, comprehensive as their evocations of time may be, they are emotionally, though not sensorily, formalized, for all (perhaps because of) their brilliance and originality of composition. As has been well said, Rubens's view is that of the lord of the manor. Such a view precludes the intimacy of human and natural interactions which Constable attains, as well as his emotional respect for the natural.

Ruisdael was a less gifted painter than Rubens, but Ruisdael's better pictures are emotionally evocative. Significantly, three-dimensional, substantial clouds looming over the foreground play a more prominent role in his art than in Rubens's. And, as in the famous *Waterfall,* there is often multifarious interplay between elements of sky, earth, and water. Sometimes in Ruisdael's pictures the wind blows, and sometimes when he portrays calm we are aware that the wind is still. His quiet scenes represent nature in action. But his treatment of clouds is unscientific. He must have observed them carefully, and he often represents them effectively, but he never portrays them as embodying sky processes. Ruisdael's clouds are, in a praiseworthy sense, evocative decorations. And his emotionality is restricted. He conveys only a kind of sombreness, a melancholy derived from an exclusion or diminishing of the human. His attitude is almost Leopardian—nature is indifferent to man in a fashion

which makes *understanding* of nature unnecessary if not impossible.[6]

I do not derogate Ruisdael or Rubens or underestimate their influence upon English artists, including Constable. But some art historians suggest Constable's achievement was only an extension of accomplishments of Dutch and Flemish realistic landscapists. Constable did learn from them, but he advanced beyond these masters because he applied to their example lessons learned from the idealized, southern, classical art of Salvatore, Claude, and Poussin. Constable was, after all, a contemporary of Turner's. As E. H. Gombrich has pointed out, it is the contrast between Constable's *White Horse* and a model for it, Hobbema's *Village with Watermill among Trees*, which is impressive and significant.[7] Nor is the influence of southern landscapists upon Constable due merely to the patronage of Sir George Beaumont, as has sometimes been implied. In fact, for over a century the art of Claude, Poussin, and Rosa affected not just painting but the aesthetic consciousness of all cultivated Europeans.

Poussin and Claude have been much studied, but Salvator Rosa, who was nearly as influential, is ignored by a majority of modern art historians. Not, though, by Kenneth Clark, who understands that one does no justice to the late Renaissance–Neo-classical sensibility toward landscape without recognizing that it was equally responsive to

> Whate'er Lorrain light-touched with softening Hue,
> Or Savage Rosa dashed, or learned Poussin drew.

Critical disparagement of Rosa arises, I suspect, from the discrepancy between his performance and his reputation. We recognize Lorrain's light touch and Poussin's powerful drawing but search in vain for savagery in Rosa's art. The century of Picasso's *Guernica* finds Rosa tame, and we tend to regard the eighteenth-century use of his

6. Ruskin's strictures on Ruisdael, for example that he painted the flow of water without either Turner's accuracy of observation or his depth of understanding, seem largely justified (see *Modern Painters,* 2nd complete ed., in 6 vols. [London, 1900], 1: 320–21, 323, 339–44, 364–65).

7. E. H. Gombrich, *Art and Illusion,* 3rd ed. (London, 1968), pp. 51–52. Conan Shields and Leslie Parris, *John Constable* (London, 1969), p. 11, quote Constable's letter to his wife from Beaumont's house reporting he "slept with one of the Claudes every night . . . If anything could come between our love it is him."

name as a synonym for horror and violence as a sign of neo-classic overrefinement. But seldom is a core of good sense absent from eighteenth-century judgments; we should perhaps consider whether we overlook something in Rosa. Ruskin, who disliked Rosa's art, nevertheless credited him with being the last believer in spirit, though despairing.

Lord Clark explains Rosa's popularity by comparing him with Byron, and attributing to him a discovery of a rhetorical form appropriate to a new vein of sentiment. But what was that vein of sentiment? Was it no more than a desire to escape from oppressive rationalism? Rosa, it is worth remembering, was not merely an Italian but also a Neapolitan. All over Italy, but especially in the south, rhetoric is a mode of dealing with the harshest truths of an existence in which life is cheap and oppression (by man or nature) is ever present. Few northern Europeans recognize the sinister *double entendre* in the pompous self-gratulation of "Vede Napoli, poi morire." Rosa was a Neapolitan artist when the city suffered under the double tyranny of counter-Reformation and Spanish occupation, when aesthetic rivalries went beyond scheming for patronage to the destruction with acid of rivals' paintings, and, if necessary, to the hired murder of inconvenient talent. The savagery of Rosa does not lie in his overt subject matter but in his use of that matter to convey the more profound and disturbing savagery concealed by the shaky grandeurs of late-Renaissance culture. He never forgets the hired bravo in the shadows behind the blue-robed madonna. The scenes and actions Rosa customarily depicts (except for battle pictures) are not per se exciting. Their function is to suggest the terrors *inside* sophisticated civilization. Rosa's sublimity consists in the revelation of the sinister within the cultivated. His trademark is a noble tree—decayed.

Consider Rosa's most influential subject, bandits in a Calabrian landscape. Whether or not he lived for a time in that environment, he understood its nature, which is the opposite of the American wilderness. Calabria is a wilderness of decayed civilizations amidst desperate persistences of ravaged nature. Two thousand years ago Cicero could say, "Magna Graecia nunc non est." Its wilderness atmosphere is not created by fecund natural growth but by evidence of repeated civilizational self-defeats, the records, so widespread as to appear casual, of the exhaustion of man's conquests of nature

through her despoilation. In Calabria men live in caves overlooking
the ruins of ancient temples. In Calabria one clambers up eroded
hillsides over the crumbled remnants of terraces built centuries ago
to hold earth weakened before that by too intense cultivation. In
Calabria refuge from pitiless heat is found among twisted remnants
of trees surrounded by the rocky glare of deforested slopes. Rosa's
bandits are not peasants but tatterdemalion nobles. They may even
be patriots. Their ragged finery, inappropriate to their surround-
ings, signal the aristocratic civility to which they were born in
Naples and from which they have fled, perhaps victims of Spanish
persecution, perhaps betrayed by their own countrymen, perhaps
out of mere hopelessness. Their tattered bravado, like the land-
scape they inhabit, embodies a self-degradation of high culture.
Even gods are banditized. In *Mercury and the Dishonest Woodsman*
the messenger of Zeus is diminished to a flitting figure between the
brightness of a denuded rockscape and the dark secrecy of a covert
of ignoble trees.

Rosa is the originator of ambiguous landscapes, and his influence
runs through two tortuous, often interweaving but still discernible
paths. One leads to Turner, probably through Alexander and Robert
Cozens, and not merely by way of the sublime Alpine scenery Tur-
ner copied from the Cozens before he had seen Switzerland. The
dark, blotchy woods and rocks on the right of *Mercury and the Dis-
honest Woodsman,* for example, could almost be transferred with-
out detection into Alexander Cozens's *New Method of Landscape,*
in which he illustrates how landscapes may be created out of ran-
domly formed inkblots. One characteristic of blot-based painting
as opposed to line-based painting is the intrinsic ambiguity of a
blot, the characteristic which makes blots useful for the Rorschach
test.[8] And, as mention of the psychological tests suggests, the am-
biguity need not be confined to multiple rational significances but
opens the way to exploitation of unconscious elements. Rosa is
significant not so much for his contribution to the sensational
sublime, the sublimity of avalanches and inundations, as to the

8. Two valuable essays on the topic are Kenneth Clark, "The Blot and the Diagram,"
Encounter 20 (Jan.–June 1963): 28–36, and Paul G. Kuntz, "The Art of Blotting,"
Journal of Aesthetics and Art Criticism 25 (1966): 93–103. Gombrich, *Art and Illusion,*
pp. 155–58, discusses the relation of Cozens's work to "picturesque motifs" deriving
from the idiom of Claude's sketches.

development of the sinister potential in sublimity, that which is out-lawed by cultivated society.

It is pleasant to turn from the doubtful effectiveness of Rosa's art to the clear magnificence of Nicholas Poussin's paintings, but for my purposes only two or three general remarks about his landscapes' difference from Constable's are germane. Along with the paintings of Claude, Poussin's pictures embody a phase in landscape repre-sentation that is as much a foreshadowing of new possibilities as a culmination of antecedent tendencies.[9] Poussin's landscapes drama-tize the reimposition upon nature of laws derived from the study of natural phenomena. Whereas earlier Renaissance artists strove to transform landscape into art, Poussin thrusts art back into landscape. This is one reason his paintings are accused of coldness: like an up-right judge he applies the law. He shapes the world, making it con-form to principles of which man alone is conscious. This is why, indeed, Poussin painted landscapes. He had no desire to escape from nature. On the contrary, as a man it was his duty and supreme pleasure to give nature the order and coherence for which it blind-ly strives but which it cannot achieve without the intervention of man's consciousness.

No one who has looked at the remarkable series of four paintings called *The Seasons,* painted near the end of Poussin's life, can main-tain that he did not enjoy nature. *Spring,* for example, reveals no pallid, intellectualized, overrefined sensibility. Never, perhaps, has the fecund vitality of nature (with no hint of mere lushness) been so powerfully presented. The least appropriate adjective for a sixty-year-old who could paint this *Spring* is "cold." Yet the pic-ture is austerely unself-indulgent. Nothing could be farther from Keatsian ecstasy at swallowing a luscious nectarine. Poussin's bal-ance between sensory richness and impersonal formality (the same "temper" exhibited in the poetry of Milton and the music of Bach) may be suggested by the double title and dual subject of the pic-ture. *Spring* is also *The Earthly Paradise,* just as *Winter* is *The Del-uge.* Poussin's *Seasons* are not merely descriptive, as is James Thom-son's poem *The Seasons* of seventy-five years later. Poussin repre-sents the essential principle of spring, that which nature would be were it to realize fully the vital potentialities which blindly surge

9. Walter F. Friedlaender, *Nicholas Poussin: A New Approach* (New York, n.d.), p. 81.

within it. The goal of life, whose energy is most manifest in spring, is eternal spring, as the goal of man's life is eternal life. We are meant to respond to *Spring* not merely as a source of sensual gratification but also as a source of rational satisfaction. We are meant to see and to enjoy the order, the form, which the artist has imposed on nature's fecundity. To put it crudely, we are meant to notice and to appreciate the artist's artistry, for without his technique there could be no earthly paradise. Our delight in the natural is that we can impose a higher order upon it, that order being not unnatural but the fulfillment of nature which it, unaided, is incapable of achieving. The act of such imposition is possibly man's supreme satisfaction, being, in fact, art, the exercise of that within us which is most human.

Critics speak of Poussin's unmitigated frontality—that in his pictures one must look straight on. A feature of this frontality is that one does not see *into*. Objects block vision. The rich foliage of the trees in *Spring* is visually impenetrable. One sees into the picture only where there are openings provided by the scene, which is one reason we are so conscious of the artful organization of the painting: our eye movements are strictly controlled. As I have suggested, pleasure lies in this control, for it is evidence of the humanity that is in the picture.[10] There can be, consequently, no surprises in Poussin. Nor is there room for Salvatoresque ambiguity, for that human vitality which finds expression, broadly speaking, in color rather than form. Evil, suggested by Salvatore by shadows, Poussin represents by serpents.

10. Ibid., p. 78. See p. 21 for Poussin's debt to classical models such as the *Aldobrandini Fresco*. Dean Mace Tolle, "*Ut pictura poesis:* Dryden, Poussin and the Parallel of Poetry and Painting in the Seventeenth Century," *Encounters,* ed. John Dixon Hunt (New York, 1971), pp. 58–81, brilliantly elucidates Poussin's art of the "passions" and its relation to seventeenth-century poetics, stressing how that century inverted Horace's simile. Tolle defines how Poussin's pictures were "discursively" interpreted by quoting freely from Fénelon's *Dialogues des morts,* for example, the passage on the slaves carrying the body of Phocion: "The first of these slaves is old; he is dressed in carelessly arranged drapery. His arms are naked and his legs show a strong and wiry man. His flesh colour marks a body used to hard work. The other slave is young, dressed in a tunic whose pleats fall with some grace. . . . and the two airs of the head are strongly varied, even though they are both servile. . . . One should not fail to notice under this confused drapery the form of the head and of the whole body. The legs are uncovered; one can see not only the faded colour of the dead flesh, but also the stiffness and heaviness of the sagging limbs" (p. 75). Tolle, incidentally, suggests that snakes held a special fascination for Poussin (see above, p. 81, note 45).

It is significant that Poussin's paintings are literary, representing the known, formalized, explicitly articulated myths of civilized society, such as association of evil with snakes. Whether he represents classical subjects (such as Phocion) or biblical ones, Poussin renders both details and total structure of his pictures amenable to discursive interpretation. Later landscapists have usually admired Poussin, and have followed him in humanizing landscape by emphasizing their mode of representation, but the greatest of his successors have turned from his myths, his kind of public appeal. One thinks of Turner and Delacroix, of course, but Constable's art, too, may be regarded as anti-Poussin, for even more decisively than Turner and Delacroix Constable avoids public, traditional mythologies. In using the Dutch genre painters as models and in striving to evoke the persistent rhythms of continuities by which ordinary and unlettered men live, Constable rejects classical rationalism. But even as Wordsworth borrowed from Milton while attempting to surpass him, so Constable's skill depends not merely on his adeptness at imitating the Dutch but also upon his ability to transform classical landscape art, of which the supreme representatives were Poussin—and Claude.

I can think of no better fashion in which to describe Claude's paintings than as dreams of an inspired pastry cook—which he is said to have been. The dreaminess of his landscapes—paradoxically —links him to Poussin: his mode of representation is intensely human. Dreaming, as impressively as reason, distinguishes man from other creatures. It is difficult, however, for post-Freudians to understand a man whose dreams were always pleasant. The key to Claude's happiness is provided by his painting of Narcissus, not his best or most typical work but revelatory of his persistent self-delight. However accurate Claude's observations of nature, actualities are subordinated to the imaginative unity of his completely self-satisfying vision. Reality in his art is ever under the enchantment of a total form of loveliness. Claude, as his careful sketches for his paintings prove, was studious, but he studied to attain pleasure in his own imaginings.

Narcissism carried too far is destructive, but a man who takes no pleasure in himself gives none to others. Beauty of body, of attitude, of movement is often inseparable from pleasurable awareness of self, and the same is true of beauty of mind. Claude's paintings

are attractive because in them we experience the enjoyable conscious-
ness of perceiving a consciously created loveliness. They are not sen-
suous, for they possess the insubstantiality of dream scenes. Perhaps
Claude painted landscapes to avoid too direct sensuousness. The
breadth and diffuseness of a natural scene permits a painter to ex-
ploit a distance, an insubstantiality, a vividness without pressing pal-
pability which makes many of our pleasantest dreams so memorable.
Indeed, landscape may be a means for distancing, displacing, sensual
fantasies so immediate, so powerful as to be threatening, fearful.
Claude was adept at rendering actual appearances of nature, but he
regularly strove for an artificial effect, a sequentiality of two-dimen-
sional forms, just as he preferred formalistically paired paintings,
and favored a tonality which diminishes the sensory impact of spe-
cific colors.[11] The Claude pattern of successive planes, the dark *cou-
lisse* to one side, the ordered ranges or layers of light intensity, are
not evidence of unimaginativeness. He aims to present nature
theatrically, to make nature a stage set, in sum, to represent a *vision*
of nature. This is why light, of secondary importance to Poussin, is
significant to Claude, for whom relationships are rendered in terms
of illumination rather than of line. But he uses a fragile, superficial
"light that never was." His far background is a luminous glow (even
his up-sun views tend to present a diffuse, subdued luminosity), and
in the middle distances we see the light playing on the edges and sur-
faces of objects, outlining, above all silhouetting, rather than pene-
trating. And light plays against light in the same superficial fashion.
The subdued brightness of the immediate foreground, balancing the
luminosity of the distant background, never embodies the energy of
light, is never active, flowing, but is merely the forward brightness
of the unchanging, steady, gentle lightness of the middle distance,
which tips the edges of objects and reveals their substance to be
nothing more than soft, impalpable shadows.

 Because Claude's pictures are theatrical dream visions, their formal
subjects are relatively unimportant—only in his later career did he

11. Gombrich, *Art and Illusion*, pp. 40–51, has a valuable discussion of implications
of the fact that it is to light intervals, gradients, that our eyes respond rather than to the
quantity of light reflecting from separate objects. One implication is that Constable's
"reform" of Claude's coloring is not a matter of substituting one set of colors for another
but of shifting his predecessor's range of tonal gradations. Constable, one might say,
transposed Claude's tune into a higher key.

exploit literary themes. Even the later pictures portray scenes of traditional mythology rather superficially. Few except scholars pay any attention to the pictures' titles. Often one cannot distinguish a classical subject from a biblical one. The literary story that is ostensibly the subject is subordinated to the scenic dream vision. Claude's position in this respect is unique. As representations of public matter his paintings are trivial, yet his art seems unsubjective. He attains the paradox of objectified narcissism. Herein lies much of his importance for later landscapists such as Constable, who, as I have pointed out, seeks an impersonality beyond impressionism and at his best is not simply subjective. Claude's dreams, one might say, are public rather than private. He utilizes conventional iconographic elements but dissolves these into a new unity of harmonious vision: referential significance is not obliterated but absorbed into a personal artifice of imagined loveliness.[12]

One should remember that the distribution of Claude's paintings makes it impossible for us to see his works in their proper context. Marcel Röthlisberger has pointed out that "over a hundred pictures, or slightly less than half the whole *oeuvre*, including all the important works, were made as pairs."[13] Besides typological formality, Claude relied upon patternings of position—a sun at the horizon to the left is rising, to the right setting—and even of color—blue representing serenity, green hope, and the like.[14] Furthermore, he detemporalized story and history. Whatever their titles, his paintings never depict events; they coalesce sequentiality into the unity of a scenic stillness.

Constable reworks Claude's static formality so as to retain something of his compositional harmony. An early picture of Dedham Vale, still apprentice work but useful to the critic because derived from Sir George Beaumont's beloved *Hagar and the Angel* by Claude, illustrates how Constable transposed Claude's dream vision of the past into a new manner of representing immediate realities as

12. Claude's dreaminess is evidenced by his mixing of architectural styles. One often overlooks how grotesquely (that is, how unhistorically) he mingles Gothic and classic elements, because, as in a dream, the incongruous is so harmoniously fused.

13. Marcel Röthlisberger, *Claude Lorrain: The Paintings*, 2 vols. (New Haven, 1961), 1: 77. Röthlisberger, incidentally, puts to rest the old story (which Constable in effect denied by praising Claude's skill at placing his figures) that the people in Claude's landscapes were inserted by other artists (p. 15).

14. Ibid., p. 26.

temporal phenomena.[15] Constable eliminates from his picture all
elements of literary iconography and conventional symbolism con-
veying public relevance, yet retains Claude's pattern of composition,
because he wants to convey something more than a single subjective
view of Dedham Vale. His aim is the coalescence of subjective view
and objective reality. He embodies in his painting a manner of see-
ing appropriate to the particular scene, so that reciprocally the
scene affirms the pleasure (we would now call it the significance) of
the perception. Claude's compositional model is useful, because it
embodies something of how we can see, specifically, a fashion in
which wish (dream) can shape perceiving.

Constable's most impressive transformation of *Hagar* is dramatiz-
ing of foreground, continuing a development begun in the Renais-
sance, when landscapes began to move forward. With Van Eyck,
landscape appears in the background; with Claude, landscape takes
over the entire picture (but he, like earlier artists, characteristically
began painting distant parts of his landscape and worked forward);
with Constable, the foreground of total landscape is emphasized.
Through *Dedham Vale*'s foreground our attention is shifted, literal-
ly, toward the realm of immediate experience, although, of course,
the foreground is not self-sufficient but part of a wider, deeper, more
permanent unity.[16]

"Get your foreground right, and the rest will follow," said Consta-
ble, summarizing one of his innovations as a landscapist. Whereas
Van Eyck often used a balcony or window ledge to cut off foreground

15. Evidence that the literal subject of many of Claude's paintings is relatively unim-
portant is provided by the beloved possession of Sir George Beaumont, probably the most
famous Claude in Britain. His *Hagar and the Angel* was subsequently identified as *The
Annunciation* in the National Gallery *Catalogue,* but the title by which Beaumont knew
his painting has returned to favor in recent years.

16. As I have perhaps implied in note 5 above, I think the history of landscape paint-
ing subsequent to Romanticism is to a significant degree the story of how foreground, the
realm of immediate experience, comes to obliterate background, how artists' search for
symbolic/metaphysical unity replaces the Romantic focus upon continuity. The romantic
emphasis is illustrated by Constable's observation, "Every tree seems full of blossom of
some kind & the surface of the ground seems quite living." The connection between
blossoming trees and *living* ground epitomizes the distinctive character of Constable's
vision. My quotation is not in this case from Beckett, but from the Catalogue to the Tate
Gallery exhibition, *Constable: The Art of Nature,* 7 June–4 July 1971 (London, 1971), p.
20, item 40a, quoting a letter from Constable to his wife of 9 May 1819, more accurately
than does Beckett. I am indebted on this point, as on several others, to Mr. Leslie Parris
of the Tate Gallery (see chapter 6, note 2, below).

Constable, *Dedham Vale* (1802). (Reproduced by courtesy of the Victoria and Albert Museum, London.)

and whereas Claude favored a soft light to introduce us gently into his dream, Constable presents a rich, tumultuously intergrown natural foreground of complex *depths*. He intrudes into the easy opening of *Hagar*'s central vista an aggressive, upthrusting bush. His foreground is naturalistically dramatic, a vigorous, varied, particularized mixture of living, aging, and dead plants. In a word, the foreground is textured. In seeing it we see into it. Life processes are brought forward so that our vision may become penetrative.

The foreground of *Dedham Vale* does not, of course, represent overt action. We see into the invisible vibrancy of solid, physical objects. The drama lies in the revelation of vitality *within* motionlessness, just as the drama of nature is that dead leaves are sources of renewed life. Constable's trees, moreover, thrust *out* and *up* and *toward* the viewer in contrast to the drooping *down* and *in* silhouetting of *Hagar*'s trees. The gentle slopes of *Hagar* are transformed in *Dedham Vale* to abrupt declivities. In comparison to Claude, Constable uses strong color contrasts. And because this richly textured, highly particularized land and plant life of the foreground carries our view into the calmer, simpler, smoother middle distance and background of *Dedham Vale,* the foreground details become functional parts of a larger, more enduring, more complex harmony of life intrinsic to the total scene. The specific and immediate connect us with, and lead us into a vision of more general life: Constable's dead leaves are aesthetically functional, as Claude's are not. Yet Constable, dramatizing life processes, can utilize the pattern of *Hagar and the Angel* (while disregarding its subject), because Claude's art unifies through mode of vision. His dreaminess, poeticness, or whatever one prefers to call it, reveals how a perceiver may shape his perceiving. One element in Constable's "realism" is his attention to the shaping activity of perception interacting with the vital powers constituting "nature," *what* we perceive.

Detailed description of the similarities and differences between Constable and Claude belongs to art history, requiring delineation of the equally potent influence of northern genre painters and of the English water-color school (the first to combine brightness of color with fluidity of form) upon Constable's understanding of Claude. But there is another aspect of Constable's relation to

seventeenth-century landscape painters. Constable's art owes something to the fact that between 1650 and 1800 there emerged in England a new kind of poetry, landscape poetry. To the origins of that art I now turn.

5
Wordsworth and
Poetic Landscape

The best general history of landscape in poetry remains John Ruskin's in *Modern Painters,* published more than a century ago. While later specialized investigations—for example, Earl Wasserman's *The Subtler Language*[1]—make Ruskin seem superficial, something like his sweeping survey is required to place literary landscape in the evolution of landscape art. And, although Ruskin can be faulted for not giving enough attention to landscapes in Roman poetry, especially those of Virgil and Ovid, his analysis of natural scenery in the *Odyssey* can scarcely be bettered.[2] He sees the leading characteristic of Odyssean landscapes to be nature as an object of practical rather than sentimental attention, and he identifies fundamental elements, such as rain and grass, as the compositional center of

1. Earl R. Wasserman, *The Subtler Language: Critical Readings of Neoclassic and Romantic Poems* (Baltimore, 1959).
2. John Ruskin, "Of Classical Landscape," *Modern Painters,* 2nd ed. in 6 vols. (London, 1900), vol. 3, chap. 13, pp. 173–95. Adam Parry, "Landscape in Greek Poetry," *Yale Classical Studies* 15 (1957): 3–29, observing that Ruskin's commentary is "by no means outdated," attempts to extend Ruskin's remarks into a discussion "of the *function* of landscape" in classical literature. One of the best portions of Parry's stimulating essay is his analysis (pp. 16–20) of "a masterpiece of landscape description" in Plato's *Phaedrus.*

classical poetry of nature. But the conclusion Ruskin draws is er-
roneous. He disregards classical landscape painting, which might
have shown him that, though classical poetry uses color words spar-
ingly and sometimes in a peculiar fashion, it is wrong to attribute
to the men of antiquity a "dim and uncertain" color sense.[3] But
Ruskin's error is instructive. In antiquity the arts were segregated:
techniques appropriate to one art—use of color in painting, for ex-
ample—were not thought of as appropriate to a sister art.[4] The
landscape art which developed in Europe from the time of the early
Renaissance expresses a breaking down of such separation and the
establishing of principles of *art* subsuming the distinct techniques
(probably originating in artisan beginnings) of diverse *arts.*

Homer, Sophocles, and the other Greek writers Ruskin cites avoid-
ed color words, I suspect, because verbal references to color are am-
biguous. A painter can apply to his canvas a particular shade of red
knowing that a viewer will see that shade. A poet using the adjec-
tive "red" knows that his readers will image in their minds shades
of red different from that in the poet's mind. Writers of antiquity
avoided such ambiguity. They used few color words, and they sel-
dom described landscapes, because verbal landscape tends also to be
ambiguous. At issue is the old distinction between the objectivity
of classical literature and the subjectivity of modern literature. But
the distinction should be a starting point rather than a conclusion.
When, for example, Coleridge in *Dejection: An Ode* speaks of a "pe-
culiar tint of yellow-green" in an evening sky he is certainly subjec-
tive as no classical writer would be. But Coleridge's phrase is re-
peated, and one assumes the poet knew he could not convey to the
reader the exact color quality of the sky he saw. Coleridge's use of
the adjective "peculiar," suggests he himself had never seen exactly

3. Ruskin, *Modern Painters,* 3: 325.
4. The segregation of artistic techniques is sometimes obscured by later classical theo-
rizing about similarity of effects, as in Horace's famous "Ut pictura poesis" passage
(*Ars Poetica,* 361-65). The importance of this doctrine in the seventeenth and eigh-
teenth centuries has been defined by Jean H. Hagstrum in *The Sister Arts* (Chicago,
1958) and R. W. Lee (see chapter 1, note 7, and chapter 4, note 10, above). The
point I wish to stress is that aesthetics as a systematized philosophy of *art*—including
the various *arts*—develops fully only in the later seventeenth century, and that its
emergence accompanies new interest in finding relations between different methods
employed by diverse arts. Raymond Williams identifies this tendency with a final sepa-
ration of the artist from the artisan, *Culture and Society, 1780-1950* (London, 1958),
especially pp. xv–xvi.

that tint before. Coleridge is engaged in communicating the incommunicable, in conveying to us a private experience that is literally unique.

What is voided in the landscape art of antiquity is emphasis on uniqueness. The generic quality of classical literary landscapes is obvious, but classical graphic landscapes tend also to be generic. Most depict literary or idealized scenes. There is no equivalent in antiquity for one of Constable's Stour scenes, any more than there is an equivalent in classical literature for Wordsworth's spots of time. The ancients never stress, as Wordsworth and Constable do, the intrinsic history of, or temporal endurances within, a natural scene, because such qualities are dependent on localization. Unless a place is localized, its specific uniqueness defined, it can not have a history.[5] The absence of time from the literary landscapes of antiquity is signalled by their exclusion of repetition, the outstanding feature of a timescape such as *Tintern Abbey*. Another missing feature is metaphor. To describe a scene by saying what it is not, which is how metaphor describes, is hardly sensible, unless one conceives, as poets of antiquity did not, the scene as the interaction of scene and viewer, as the coalescence of subject and object, as an *experience*. And the relative scarcity of literal metaphor in classical descriptions is symptomatic of broader omissions. I know of no example from antiquity of landscape comparisons, juxtaposition of different scenes, the kind of comparison brought to a climax by Wordsworth, who even compares (by superimposing) a scene with itself, and, in *Peele Castle*, compares a real scene with its painted representation.[6]

Ruskin justifiably treats Dante as the exemplar of medieval literature, but I will use Chaucer to exemplify what seems to me a neglected characteristic of medieval literary landscapes, which are, of course, predominantly gardenscapes.

> With that myn hand in his he tok anon,
> Of which I confort caughte, and went in faste.
> But, Lord, so I was glad and wel begoon!

5. Chinese landscape seems to us to have remained frozen in its classicism because it appears never to have developed an art of unique locale and of intrinsic historicalness.

6. Monroe C. Beardsley's discussion of metaphor is particularly useful for understanding of the broad, generic distinctions I am trying to clarify: "A metaphor is an indirectly self-contradictory or else an obviously false attribution . . . metaphor does not create the connotations, but it brings them to life" (*Aesthetics* [New York, 1958], p. 134).

For overal where that I myne eyen caste
Were trees clad with leves that ay shal laste,
Ech in his kynde, of colour fresh and greene
As emeraude, that joye was to seene.

The byldere ok, and ek the hardy asshe;
The piler elm, the cofre unto carayne;
The boxtre pipere, holm to whippes lashe;
The saylnge fyr; the cipresse, deth to playne;
The shetere ew; the asp for shaftes pleyne;
The olyve of pes, and eke the dronke vyne;
The victor palm, the laurer to devyne.

A gardyn saw I ful of blosmy bowes
Upon a ryver, in a grene mede,
There as swetnesse everemore inow is,
With floures white, blewe, yelwe, and rede,
And colde welle-stremes, nothyng dede,
That swymmen ful of smale fishes lighte,
With funnes rede and skales sylver bryghte[7]

Chaucer's landscape is a paradisial enclosed garden, a *locus amoe-nus*. The Latin phrase should not mislead us into thinking of para-dise as a classical conception, despite the Graeco-Roman theme of the Golden Age. Perhaps paradise is a Jungian archetype, but the Christian development of the paradise myth is so rich and intense that, whatever its origin, it may be treated as a specifically cultural rather than a generically psychological phenomenon. The difference in degree between Western Christendom's exploitation of the Edenic myth and that of any other culture I know is so vast as to become a

7. *The Parliament of Fowls*, ll. 169–89. My quotation is from *The Poetical Works of Chaucer*, ed. F. N. Robinson, Cambridge ed. (Boston, 1933), p. 365. The subject of medi-eval and Renaissance allegoric landstapes, particularly gardenscapes, is, of course, an enor-mously complicated one, which I am not competent to elucidate. An interested non-specialist might do well to start with a survey of the monumental Arthur O. Lovejoy, George Boas, *et al., Documentary History of Primitivism and Related Ideas* (Baltimore, 1935), which suggests the difficulties of definition underlying any study involving nature in art, before taking up the elegant studies of distinguished medivalists such as Lewis, Vinaver, and Robertson. E. R. Curtius, *European Literature and the Latin Middle Ages* (New York, 1953) is of course basic—I would cite as exemplary the detailed description of how the Vale of Tempe inspired later depictions of the *locus amoenus* (pp. 198 ff). A succinct account of the process of such influence on Renaissance poets and critics is Wil-liam Nelson's tracing of the effect of Servius's interpretation of Virgil's *silva*, *The Poetry of Edmund Spenser* (New York, 1963), pp. 158–62.

difference in kind.[8] And the difference helps one to understand how the medieval representations of a "nature beyond nature," while a regression from some natural landscapes of antiquity, may have contributed to later advances in literary landscape.

Chaucer's garden represents what is beyond ordinary experience of the actual world *by means of* objects of the natural world. Intimations of the suprasensory are attained through the sensory, and in this respect Chaucer's garden is closer to Wordsworth's Wye valley and Grasmere than to Virgil's Italian countryside scenes in the *Georgics.* Van Eyck's landscapes may help us to understand why Chaucer appears in this position. In the *Adoration of the Mystic Lamb,* for instance, the scene is exceedingly formalized, and the plants appearing are an impossible mixture of Mediterranean and Northern European flora. Yet each plant in itself is represented with naturalistic precision. Van Eyck's favorite plant, interestingly, is the humble and ubiquitous dandelion. If we leave aside for the moment symbolic significance, we have to be impressed by Van Eyck's realism: the extensive greensward he portrays would, in fact, be covered with dandelions. This draws our attention to the surprising greenness of Van Eyck's slopes, a greenness of vista not again equalled until Constable's day. It is a greener landscape than any appearing in Renaissance or Baroque pictures that helps to dramatize the supersensuous reality which the *Mystic Lamb* celebrates.

Though Chaucer's garden is not so green, it is organized in analogous fashion and to much the same effect. Chaucer's arrangement is conceptual. Flowers are distinguished by color, not by where and how they grow, just as trees and animal life are enumerated without regard for naturalistic *patterns* of relationship. Chaucer's description is a list, as in fact Van Eyck's painting "lists" thirty-six different species without regard to ecological probabilities. As Chaucer's adjectives reveal, he represents each thing in itself; he has no interest in the relations among natural phenomena. He provides us with what might be called a denotative extravaganza. As in Van Eyck's landscape, no one thing is like any other thing. All we know about the flowers, for example, is their differences in color. And

8. Few modern literary critics will agree with my remarks about paradise. One different view appears in John Armstrong's intriguing, if not entirely persuasive, *The Paradise Myth* (London, 1969).

the conventional epithets, "The sayling fyr; the cipresse, deth to playne," are above all else discriminative. Hence Chaucer's landscape, like Van Eyck's, is static—as an Edenic spot ought to be. For the ultimate contrast, one might look at Charles Darwin's paragraph on an entangled bank concluding the *Origin of Species*.[9] What fascinates Darwin—entanglement, interconnections in both time and space—is of least interest to Chaucer, because the medieval garden is beyond nature. Chaucer's lists prevent us from becoming entangled in actual relations, so the formal order of the passage is appropriate to the delight of passing through nature into a ravishing supersensuous experience. A *locus amoenus* is enchanting because it is naturalistically unlocatable and, because unlocalized, free from temporal complexities.

To trace out the emergence of temporalized landscape poetry, one may distinguish what I call, arbitrarily, a topographical line of development from pastoral. Spenser, to cite an obvious example, contributes little to landscape poetry. Pastoral is organized aesthetically and psychologically, and is based upon deliberately transparent disguise: a courtier who mistook Marie-Antoinette for a genuine milkmaid would not have been welcome at Versailles.[10] The

9. Darwin's paragraph (modified in later editions) is of enough interest to anyone studying landscape to justify quotation. "It is interesting to contemplate an entangled bank, clothed with many plants of many kinds, with birds singing on the bushes, with various insects flitting about, and with worms crawling through the damp earth, and to reflect that these elaborately constructed forms, so different from each other, and dependent on each other in so complex a manner, have all been produced by laws acting around us. These laws, taken in the largest sense, being Growth and Reproduction; Inheritance which is almost implied by reproduction; Variability from the indirect and direct action of the external conditions of life, and from use and disuse; a Ratio of Increase so high as to lead to a Struggle for Life, and as a consequence to Natural Selection, entailing Divergence of Character and the Extinction of less-improved forms. Thus, from the war of nature, from famine and death, the most exalted object which we are capable of conceiving, namely, the production of the higher animals, directly follows. There is grandeur in this view of life, with its several powers, having been originally breathed into a few forms or into one; and that, whilst this planet has gone on cycling on according to the fixed law of gravity, from so simple a beginning endless forms most beautiful and wonderful have been, and are being, evolved" (Charles Darwin, *On the Origin of Species*, A Facsimile of the First Edition, with an Introduction by Ernst Mayr [Cambridge, Mass., 1964]). In juxtaposing Chaucer and Darwin, I do not mean to obscure the absolute opposition of their views, neatly summarized by Mayr in his introduction by the terms "population thinking" and "typological thinking" (pp. xix-xx).

10. See Elizabeth Sewell, *The Orphic Voice* (New Haven, 1960), pp. 169-275, for the best extended discussion of the relation between scientific taxonomy and nature poetry. Obviously my thinking about pastoral is influenced by William Empson, *Some Versions of*

special illusionism of pastoral is antithetical to entanglements of realistic topographical poetry.

But the illusionism of Elizabethan drama, especially in the plays of Shakespeare, contributed to topographical art. This popular drama was also relatively naturalistic. And the bare platform stages of English theatres, which contrast with their contemporary counterparts on the continent, fostered growth of topographical imagination. The Prologue in *Henry V* calls upon capacities in his audience which had been encouraged by Elizabethan playwrights' skill at using language to substitute for elaborate scenic effects. There are hundreds of places in Shakespeare's plays where with a few lines, or even a few words, dialogue sketches an imaginative scenic context for the action. To suggest the importance of Shakespeare's influence, which must receive a share of the credit for British primacy in landscape poetry, I cite an extreme example, because it is well known: Edgar's depiction of the fictitious cliff in front of the blinded Gloucester.

> Come on, sir; here's the place. Stand still. How fearful
> And dizzy 'tis to cast one's eyes so low!
> The crows and choughs that wing the midway air
> Show scarce so gross as beetles. Halfway down
> Hangs one that gathers sampire—dreadful trade;
> Methinks he seems no bigger than his head.
> The fishermen that walk upon the beach
> Appear like mice; and yond tall anchoring bark,
> Diminished to her cock; her cock, a buoy
> Almost too small for sight. The murmuring surge
> That on th' unnumb'red idle pebbles chafes
> Cannot be heard to high. I'll look no more,
> Lest my brain turn, and the deficient sight
> Topple down headlong.[11]

Pastoral (London, 1935). Frank Kermode's introduction to *English Pastoral Poetry* (London, 1952) I have also found useful. A different approach to the subject will be found in Harold E. Tolliver, *Pastoral: Forms and Attitudes* (Berkeley and Los Angeles, 1971), especially pp. 177-259. Thomas G. Rosenmeyer, *The Green Cabinet: Theocritus and the European Pastoral Lyric* (Berkeley and Los Angeles, 1969), provides a thoroughgoing discussion of the origins of pastoral and makes an excellent contrast to Empson, Poggioli, and other modern speculators upon pastoral who approach it by way of its later developments. Rosenmeyer demonstrates clearly that in its origins pastoral lyric *avoids* descriptions of nature (see especially chapter 9, pp. 174-203).

11. *King Lear,* IV, vi, 11-24. I quote from *William Shakespeare: The Complete Works,* general editor Alfred Harbage (Baltimore, 1969), pp. 1093-94.

The illusion here is distinct from the translucent concealments of the pastoral. The audience sees there is no precipice, sees that Gloucester is being deceived. The effectiveness of Edgar's speech depends upon its creating in the audience's imagination so vivid a picture that the audience would be surprised if Gloucester did not leap. This example may stand as evidence that in disregarding Shakespeare's role in the development of literary landscape art I omit a feature of importance. My excuse is that were I to enter the marvelous world of Shakespearean drama I might not re-emerge.

I turn, instead, to what will lead directly toward Milton: the Puritan Revolution. Although this was, for a civil war (the worst of wars) relatively unferocious and undevastating, it did compel many Englishmen to attend to the topography of their country, as armies marched, countermarched, and maneuvered. Literary scholars probably underestimate the long-term importance of the military development of topographical mapping, particularly its emphasis upon unique land shapes of particular locales, and its creation of methods for systematized descriptions permitting comparison of locales related by configuration though geographically separate. Milton describing Paradise, however, owes more to literary tradition than to military maps.

> *Eden* stretch'd her Line 210
> From *Auran* Eastward to the Royal Tow'rs
> Of Great *Seleucia,* built by *Grecian* Kings,
> Or where the Sons of *Eden* long before
> Dwelt in *Telassar:* in this pleasant soil
> His far more pleasant Garden God ordain'd; 215
>
>
> Southward through *Eden* went a River large, 223
>
>
> Rose a fresh Fountain, and with many a rill 229
> Water'd the Garden; thence united fell
> Down the steep glade, and met the nether Flood,
>
>
> How from that Sapphire Fount the crisped Brooks, 237
> Rolling on Orient Pearl and sands of Gold,
> With mazy error under pendant shades
> Ran Nectar, visiting each plant, and fed 240
> Flow'rs worthy of Paradise which not nice Art
> In Beds and curious Knots, but Nature boon
> Pour'd forth profuse on Hill and Dale and Plain,
> Both where the morning Sun first warmly smote

The open field, and where the unpierc't shade 245
Imbrown'd the noontide Bow'rs: Thus was this place,
A happy rural seat of various view:
Groves whose rich Trees wept odorous Gums and Balm,
Others whose fruit burnisht with Golden Rind
Hung amiable, *Hesperian* Fables true, 250
If true, here only, and of delicious taste:
Betwixt them Lawns, or level Downs, and Flocks
Grazing the tender herb, were interpos'd,
Or palmy hillocks, or the flow'ry lap
Of some irriguous Valley spread her store, 255
Flow'rs of all hue, and without Thorn the Rose:
Another side, umbrageous Grots and Caves
Of cool recess, o'er which the mantling Vine
Lays forth her purple Grape, and gently creeps
Luxuriant; meanwhile murmuring waters fall 260
Down the slope hills, disperst, or in a Lake,
That to the fringed Bank with Myrtle crown'd,
Her crystal mirror holds, unite their streams.
The Birdes thir quire apply; airs, vernal airs,
Breathing the smell of field and grove, attune
The trembling leaves, while Universal *Pan*
Knit with the *Graces* and the *Hours* in dance
Led on th'Eternal Spring.[12] 268

Full analysis of this description would require reference to such
observations as Arnold Stein's that in this first view of Paradise we
see Paradise *lost,* because we see it through the eyes of Satan.[13]
Leaving such aspects of a complete reading aside, I observe only
that Milton presents a landscape. Though features of the medieval
garden remain, Milton's scene has both the extent and intricate
richness of a large natural vista. He does not organize by listing,
which would be inadequate to the articulated complexity that is
a central characteristic of his Eden. One must be impressed, too,
by the range of specific sensory appeals, "all delight of human

12. *Paradise Lost,* bk. iv, ll. 210-68. I quote from *John Milton: Complete Poems and Major Prose,* ed. Merritt Y. Hughes (New York, 1957), pp. 282-84.

13. Arnold Stein, *Answerable Style: Essays on Paradise Lost* (Minneapolis, 1953). There are many fine later studies of Milton's art, but Stein's work first alerted me to several aspects of Milton's style significant to landscape poetry. Stanley Fish, *Surprised by Sin: The Reader in Paradise Lost* (London and New York, 1967), locating the form of the poem in the reader's experience of it, by implication would support my emphasis on Milton's organization through sound, though Professor Fish is not much interested in aural characteristics.

sense." As with Poussin, however, sensual richness never becomes indulgence. Throughout, Milton conveys a feeling for that art beyond "nice Art" which is the organizing principle of nature pouring "forth profuse," the intrinsic directedness of the living water "wand'ring" in "mazy error," the controlling design within the wealth of apparently "luxuriant" wantonness. One feature of this inner order is, to be sure, discriminativeness. Though here, as is not true in Chaucer's garden, sensory *response* to objects is evoked, sensations are not mingled. Milton uses little synaesthesia. Nor is there in our progress through Eden experiential mingling of present sensation with that just past or with anticipation of sensations to come. Though sensorily richer, more complicated, more interrelated than Chaucer's scene, Milton's is still founded on a primary consciousness of the separateness of things. Objects are defined by their difference from other objects. Even the geographic placing of the garden in introductory and concluding lines may derive from a desire to discriminate, for the lines distinguish Eden within a larger geographical and cosmological context.

Yet Milton's desire to *place* Eden (analogous to his desire to place the earth cosmologically) is an impulse to geographic localization foreign to medieval writers. And there is in Milton's description a new dimension of relationship, suggested by linking words such as "thence," "where," "Betwixt," "Another side." The suggestion of systematic description conveyed by these words, however, is not realized by pictorialization of detail. It is impossible to determine the physical relations of groves, caves, brooks, and valley. This spatial "incoherence" is reinforced by temporal references—"morning Sun," "noontide," "meanwhile"—which in fact do not establish coherent sequence. But Milton's presentation of "Eternal Spring" can be called incoherent, as Chaucer's cannot, because the earlier poet makes no pretense of representing features through their spatial relationships. Milton uses such pretense to render an order more profound, if one wishes, more intellectual. Precisely the incoherence revealed by inspection of Milton's conjunctive words permits an illusory pattern to embody a more intricate and subtle unity of sound.

Milton does not attempt to paint a picture with words. He exploits the sensorily (especially visual) referential qualities of words to create an audial presentation of Paradise. Poetry, after all, is

aural, not visual. It is composed of sounds, yet not pure sounds, like music, but the sounds of speech, utterance of intellectual meaning. Indeed, because the underlying structural systems of poetry are patterns of "impure" sounds, landscape poetry is fascinating—the visualization demanded by its subject matter is, to some degree, inappropriate for poetry. And Milton, it seems to me, understood this inappropriateness. Consistently, though in diverse fashions, he articulates principles more through the rhythm of impure sound than through an ordering of visual imagery. His method is apparent where there is an onomatopeic pattern, as in line 261, where "disperst" (carrying its Latin connotation) breaks off the flow of the preceding "meanwhile murmuring waters fall/ Down the slope hills." More important, but more difficult to describe, are the larger rhythms in which sound more subtly organizes visual references. In lines 252–63 spatial incoherence functions as a profusion to be controlled, crudely, by the regularity of the meter, and, more subtly, by sound patterns operating both within and across lines. The patterns are signalled by Milton's fluidity of syntax and his artful placing of words and phrases, which lead us to respond to semantic meaning or imagistic force of a word as a function of its role in the inclusive sound structure of the long period.

Illustration of this artistry is tedious, but we may glance at the interplay of "l" and "r" sounds—one notes the alternation of "l" emphasis and "r" emphasis in lines 252–55, which is then modulated with "r"-slanted "umbrageous Grots" (256–57), leading to the balanced "cool recess" lines (258–59), then the "l"-slanted "waters" lines (260–61), returning finally to "r"-dominant lines 262–63, the last containing a denser concentration of "l"s and "r"s than any of the preceding ten lines, particularly in the phrase before the caesura, "Her crystal mirror holds." One may observe too the shift from the "fl" motif in the first lines of the passage (Flocks, flow'ry, Flowers) to the "tl" motif in subsequent lines (mantling, gently, Myrtle) as reinforcing yet complicating the simple "l" and "r" patterns.

As for word placing and syntax fluidity, one might note the skillful intrusion of the phrase in line 262 and the first half of 263 which enables the poet aurally to conjoin two verbs which syntactically "ought" to be separated: "holds, unites," The disjunctive-juxtaposition defines the fashion in which the "murmuring waters . . . disperst" are *both* controlled *and* self-controlling, how their free-flowingness fulfills a principle of harmonious order.

The features of Milton's art I emphasize also appear in the famous lines, introduced by the reference to Pan, immediately following my quotation, "Not that fair field/ of Enna" and on through seventeen lines filled with literary, geographical, and mythological references to paradises "wide remote/ From this *Assyrian* garden." Such references bring to mind Poussin. Just as Poussin was too fine a painter merely to retell antique stories, so Milton was too fine a poet to exploit the classics for mere imagistic effect. The profusion of his references does not so much call up pictures in the reader's mind as evoke a diversity of sensuous and intellectual connotations, all marshalled, all controlled, by their role in an underlying rhythmic harmony of the sound patterning which provides the primary structure of the passage. No pattern of visual images by itself could convey the *discipline* of this richness of metaphoric reference—and for Milton, paradise *is* disciplined profusion.

The organizing primacy of sound, however, need not distract us from the historical dimension in these seventeen lines. One function of the multitude of classical references is to distance Eden from us, to dramatize its loss by reminding us of the history that has flowed on since the expulsion of our first parents, to present "th'Eternal Spring" in the perspective of time, and time in the perspective of eternality, even as the great Christian truths are represented in the perspective of errors of pagan art and religion: "Hesperian Fables true,/ If true, here only." But even in thus admitting time into the eternal garden Milton shows himself a man of his times. He tells us that the loss of paradise brings on the seasons, and *Paradise Lost* did in fact lead to *The Seasons*. By the mid-seventeenth century Renaissance historical consciousness had developed too far to be suppressed, and that development, as much as any "love of nature," led to the triumph of landscape poetry, which, finally, is a poetry of time through specification of the uniqueness of *a* place.

Before turning to John Denham's historical specification, however, I want to anticipate my later comment on Wordsworth's vision from Mt. Snowdon. In the Snowdon passage Wordsworth attains an effect Milton did not desire, poetic chiaroscuro. Milton did not lack the talent to achieve the intense interactiveness of Wordsworth's description, and few would argue that he possessed a less synaesthetic imagination. But Milton, like Poussin, represents the natural through the supernatural. Wordsworth's poetic chiaroscuro depends upon his determination to represent the supernatural *in* the natural.

Differences in technique stem from differences in spiritual commit-
ment, yet such differences do not preclude important affinities be-
tween the two poets. In poems by Denham, Pope, and Thomson,
to be discussed shortly, the supernatural plays a minor part. So,
while developing the poetic methods of his more immediate prede-
cessors, Wordsworth returns to attitudes of mind and spirit charac-
teristic of Milton. Perhaps many significant artistic innovations
consist in a combination of technical advance with spiritual regres-
sion. Were this not so, it would be even more difficult than it is to
explain why the arts do not improve yet do possess a discernible his-
tory. In any event, it is notable that not until the end of the eigh-
teenth century will we encounter a literary landscape as dependent
upon sound—the essence of poetry—as are the landscapes of *Para-
dise Lost.*

 Lord Clark has observed that light is crucial to landscape painting
because it represents the transitory.[14] A graphic landscape is *a* view;
it portrays a unique conjoining of diverse elements, for weather,
growth patterns, even geological conditions are not constant. You
can never see the same landscape twice, except in a picture. The
painter's primary embodiment of this intrinsic transitoriness is
light, a form of energy that exists only kinetically. Vital to great
landscape painting, therefore, is chiaroscuro, wherein the full emo-
tional power of light emerges. But in landscape poetry light is meta-
phorical, and poetry itself is temporal. sequential. Yet a landscape
poem, too, endures without significant change. In it nature's muta-
bility is fixed, an impression is preserved, a topographical event be-
comes an aesthetic image. Landscape poetry's equivalent to chiaros-
curo is history, and the evolution of landscape poetry is inseparable
from changing conceptions of time and man's life in time.

 History is essential to Sir John Denham's *Coopers Hill,* usually re-
garded as the first important "prospect" poem and identified by
Dr. Johnson as the fountainhead of what he called "local poetry,"
the main subgenre in which landscape poetry developed. First
composed between 1640 and 1642, the poem expressed Denham's
Royalist sympathies, suggesting that were King Charles pressed too
hard by his subjects, he would be driven to unleash his destructive

14. Kenneth Clark, *Landscape Into Art* (1949; Boston, 1961), pp. 14–15, 24–25, 41,
passim.

powers. The threat appears most notably in a final simile compar-
ing the king to a river that overflows its banks when too confined.
A dozen years later when Denham revised *Coopers Hill* into the
form in which it was subsequently best known, he modified the po-
em to accommodate it to the events of the intervening years. The
Royalist forces had been defeated by the Puritan New Model army;
King Charles had been beheaded; Denham, whose estates had been
confiscated and who had been driven into exile, was living in Eng-
land again under the protection of the Earl of Pembroke, a member
of the Council of State of Oliver Cromwell, who in December of
1653 became Lord Protector. The core of Denham's revision is
generalization, which suits the poem's basic emblematic or hiero-
glyphic mode.[15] By removing overt references to Charles I, he turns
the poem into a celebration of the virtue of balancing political
forces transforming his climactic simile to a comparison between
the river and the power of the state. When, after the Restoration,
Denham reissued the poem, he made no important changes in his
revision of 1653–54, revealing that in accommodating his original
work to actualities of the mid-fifties he had arrived at a satisfactory
expression of his "argument," the need for "*concordia discors*" in
social-political life.

Denham's "prospect" is determined by events of political history.
Cooper's Hill is not high, but it overlooks the Thames Valley. Lon-
don, or its haze, is visible from the hill, and in Denham's day the
dome of St. Paul's may have been, as he says, conspicuous. Obvious
even today are the royal residence and "forest" of Windsor, and St.
Anne's Hill, which in the seventeenth century still showed the ruins
of a chapel despoiled by Henry VIII. At the foot of Cooper's Hill
is a marshy tract, an overflow area for the Thames in flood, known
as Runnymede, where King John signed the Magna Carta. One

15. Though my comments on *Coopers Hill* owe something to Earl Wasserman's chapter
in *The Subtler Language* (Baltimore, 1959), I am primarily indebted to Brendan O'Hehir,
Expans'd Hieroglyphics (Berkeley and Los Angeles, 1969), from whose "B" text (that of
1668), pp. 137–62, all of my quotations are taken. John Wilson Foster, "A Redefinition
of Topographical Poetry," *Journal of English and Germanic Philology* 69 (1970): 394–
406, relates Denham's poem to Jonson's *To Penhurst* and to subsequent eighteenth-cen-
tury developments, not entirely escaping the tendency we all have to read these poems as
exemplifications of philosophic or poetic theories. A corrective is provided by Joseph
Anthony Mazzeo, "A Critique of Some Modern Theories of Metaphysical Poetry," now
in *Seventeenth-century English Poetry*, ed. William R. Keast (New York, 1962), pp. 63–74.

could not invent a better prospect for a survey of English history.

The multiple historical aspects of *Coopers Hill* go far to account for the fame and influence of the poem. Denham's adherence to the doctrine of *concordia discors* (examined by Wasserman), and his employment of the hieroglyphic mode (explained by O'Hehir) are not in themselves enough to account for the poem's popularity or its function as prime model for "local" or "landskip" poetry. The concept of *concordia discors* makes practical sense when applied to the vicissitudes of the civil war. It happens, too, that landscape art *must* be organized by something like a system of *concordia discors,* harmonizing disparate features, so that in Denham's poem there is a happy conjunction of idea and embodiment, a conjunction later poets could imitate, even though using different ideas and different modes of embodiment. Similarly, Denham's emblematic method, because of the personal and political cogency of the particular situation, becomes something more than an exercise in a popular literary technique and can function to reveal lasting truths within political-religious-economic turmoil. This is why *Coopers Hill,* although, as O'Hehir observes, not *about* landscape, could become a model for poetry that was about landscape. The best such poetry, of course, is never merely descriptive and is always emblematic in some fashion: it is landscape *art.* Denham, inadvertently, as it were, demonstrated how a real vista could represent practical, rather than theoretical, significancies. In its final form *Coopers Hill* presents not abstruse doctrines for the learned but a historical lesson of the Puritan revolution. Its final simile is powerful because it emerges out of the exigencies of the poem's composition and revision, above all fratricidal war, and it defines the dangerous power that is any political state.

Cooper's Hill is a real hill with a view of an actual stretch of English landscape authentically rich in historical associations. In the final version, conventional harmonizing of scenic contraries, "The steep horrid roughness of the Wood" with the stream "transparent, pure, and clear," the clouded mountain peak with the plain sheltered by its loftiness, is focused by the river Thames, most notably in the couplets praised by Dryden which introduce the descriptive core of the poem.

> O could I flow like thee, and make thy stream
> My great example, as it is my theme!
> Though deep, yet clear, though gentle, yet not dull,
> Strong without rage, without ore-flowing full.
> (ll. 189–92)

The lines could describe Wordsworth's poetic ideal. The river can be both Denham's example and theme (as Wordsworth wanted the river Duddon to be for him), because he sees the river as an active principle interconnecting features that otherwise would be but the abstract contraries of the Renaissance square of oppositions, moist-dry, fire-water, etc. To Denham the Thames is literally as well as metaphorically the vital stream of England's life, for it is the source of England's interaction with the rest of the world (ll. 181–88). And it is the commerce the river makes possible, along with the agricultural bounty of its fecundating flow, which is ravaged by civil war.

The historical vigor of Denham's emblems for us tends to be obscured by his reliance on the georgic tradition. The main fact about the georgic is that it is a formal model. Denham writes by shaping his subjective experience to the demands of an impersonal decorum; the occasion of his inspiration is adapted to a culturally defined pattern. Wordsworth, in contrary Romantic fashion, adapts such patterns to the occasion of his inspiration and shapes pre-established forms to his subjective experience. But Wordsworth successfully inverts Denham's relation to tradition because neoclassic descriptive poetry in the intervening century and a half had eroded the strength of poetic decorums. The key poem, of course, is Thomson's *Seasons,* which is almost purely descriptive. Not by accident Thomson emphasized the sublime, for by definition what is sublime is beyond rule, outside decorum. Sublimity was a major force in breaking up categories upon which earlier poetry had depended. But to appreciate the function of this negative power in landscape poetry, one must at least glance at the positive aesthetic of *Windsor Forest,* which utilizes Denham's "local poetry" arrangement as a means for adapting the Virgilian georgic to modern conditions and allowing it to combine with disparate, subordinate models, such as the Ovidian tale.[16]

16. On Pope I have used Maynard Mack, *The Garden and the City: Retirement and Politics in the Later Poetry of Pope* (Toronto, 1969), Reuben A. Brower, *Alexander Pope: The*

Pope, however, foregrounds what had played a minor role in Denham's poem, "retirement" as a social ideal:

> Happy the Man whom this bright Court approves,
> His Sov'reign favours, and his Country loves;
> Happy next him who to these Shades retires,
> Whom Nature charms, and whom the Muse inspires,
> Whom humbler Joys of home-felt Quiet please,
> Successive Study, Exercise and Ease.[17]
>
> (ll. 235–40)

These lines, and those immediately succeeding, are the climax of the first part of *Windsor Forest,* their effect depending on their following realistic portrayals of the Windsor scene. But there is never any lack of art in Pope's realism. Lines 17–25 might be called the best verbal Claude landscape in English, though a function of the lines' artifice is to establish the actuality of that patriotic *locus amoenus* where "Peace and Plenty tell, a STUART reigns," where the fictional bounty of Olympian gods is in fact realized. Tracing the course of English history, Pope never fails to provide patterns appropriate to a well-formed artefact. Thus, to cite a small example, he represents the effect of the Norman conquest by a "ruins" picture in which pluralization sustains reference to the condition of England as a whole, while the succinctness of the statements in the taut couplets maintains the force of the disaster as a specific event.

> The Fields are ravish'd from th'industrious Swains,
> From Men their Cities, and from Gods their Fanes:
> The levell'd Towns with Weeds lie cover'd o'er,
> The hollow Winds thro' naked Temples roar:
>
> (ll. 65–68)

In the celebrated pictorialization of the mortally wounded pheasant

Poetry of Allusion (London, 1959), and Martin Price's comments in *To The Palace of Wisdom* (Garden City, 1964). Mack argues persuasively for profound connections between Pope's politics and the quality of his retirement at Twickenham in his later verse, and I believe, though Mack does not make the point, that *absence* of such profound, intense connection weakens *Windsor Forest.* Jeffrey B. Spencer, *Heroic Nature: Ideal Landscape in English Poetry from Marvell to Thomson* (Evanston, 1973), is not as helpful as I had hoped but usefully emphasizes the importance of art in Pope's "natural" descriptions (pp. 214–15).

17. All quotations from *Windsor Forest* are from the Twickenham Edition of the *Poems of Alexander Pope,* volume 1, *Pastoral Poetry and the Essay on Criticism,* ed. E. Audra and Aubrey Williams (New Haven, 1961).

(and, indeed, throughout the ingenious calendric art of lines 93–146) Pope does not allegorize, so his claim that "gentlemanly" hunting and fishing embody the physical-spiritual liberty of Britain's "vig'rous Swains" carries conviction. Most skillful is his invention of a classical myth of Lodona, who, fleeing from Pan, was transformed into the river which bears her name, and who appears, finally, as imaging the landscape that is the poem's subject—an artifice out-Oviding Ovid that, nonetheless, keeps the poem's focus upon existent, circumstantial reality.[18] Lodona's fate, inspiring aesthetic vision by actually mirroring the real world, epitomizes Pope's ambition—to create an art adequate to the social-political importance of the natural facts of Windsor.

If *Windsor Forest* is not entirely successful, its weakness lies in the banality of Pope's panegyric of the Establishment because it is established. Precisely the fineness of discrimination and the sharpness of contrasting arrangements which make his pictures of the dying pheasant and the reflected landscape so memorable (qualities which sustain Pope's marvelous later satires and political verse) are missing from the politics of *Windsor Forest.* And it is this early poem of Pope's which is most imitated by later eighteenth-century poets retiring into description without Pope's visual acuity and gift for impeccable verbal structure. Because so much of the topographical verse of the century keeps to the complacent affirmations of *Windsor Forest*'s politics (unlike Pope's later, sharp Tory polemics), Romantic nature poetry may seem to us quite original in using localized scenes as foci for unconventional criticism of accepted value systems. Romantic retirement serves as a base from which to attack not just different political views but even fundamental cultural presuppositions. Retiring into solitude for the Romantics is a means of exercising profound aspirations. Providing an Archimedean "place to stand" (as Wordsworth observes in his prefatory note to the *Intimations Ode*), solitude enables the Romantic to move his mind and so to move the world. Thus a key Romantic paradox: withdrawal leads to joyful participation.

Pope's Tory politics and classical culture cut him off from that kind of pleasure.[19] *Windsor Forest,* celebrating a specific national

18. On the origins of Lodona, see David R. Hauser, "Pope's Lodona and the Uses of Mythology," *Studies in English Literature* 6 (1966): 465–82.
19. See Louis I. Bredvold, "The Gloom of the Tory Satirists," in *Pope and His*

policy, rule by the Stuarts in the person of Anne, and a specific international policy, imperialism, reminds us that Pope's dependence on the model of Virgil's *Georgics* is not solely a matter of form. Virgil supported the imperial pretentions of Augustus embodied in the *pax romana*, a peace imposed by Roman militarism on peoples whose subjugation enriched Roman merchants. In *Windsor Forest* Pope foresees a *pax britannica*, established by the Peace of Utrecht, enabling British mercantile interests to take advantage of less advanced countries. His title is revealing. "Forest" was "a legal rather than a topographical term, and referred specifically to a land outside (*foris*) the common law. Such land was subject to a special law which aimed at setting aside and preserving certain territory for the king's recreation."[20] Until well on into the eighteenth century, topographical poetry tended to treat land symbolically at least "outside the common law," implicitly confirming the hierarchism of *Windsor Forest*. An artistic consequence was fondness for prospects, because poets were distant from the land they described, how literally distant the contrasting poetry of Robert Burns and John Clare makes plain. The figurative distance of neoclassic poets from nature is marked off by their tendency to seek it merely for recreation, and again the contrast provided by Burns and Clare is instructive.

The political bias of *Windsor Forest* appears most significantly, however, in the poem's style, especially in its rationalized diction, syntax, and metrics. Even through the *form* of his natural descriptions Pope represents empire, monarchy, and mercantilism as reasonable. He says little about weather, perhaps, because weather is not very susceptible to rational systematization. Weather resists control. For Pope nature must subserve reason; like many of his successors, he wants to look down on rationally subjugated terrain. So one detects a latent aggressiveness toward the natural world mixed with the poet's genuine fondness for it. *Windsor Forest* is farthest from the Romantic in its lack of passivity and receptiveness. Pope's rational retirement excludes interplay between man and nature, interplay crudely adumbrated in *Ossian*, delicately evoked in Cowper's *Task*, and diversely celebrated by Romantic poets as inter-

Contemporaries, ed. James L. Clifford and Louis A. Landa (Oxford, 1949), pp. 1–19. See also Thomas R. Edwards, *Imagination and Power* (New York, 1971), pp. 106–18.

20. *Pastoral Poetry*, pp. 135–36. Brower, *Alexander Pope*, pp. 35–62, presents a masterful critique of the poem.

penetration—an interpenetration precluded for Pope by his cultural and political commitments.[21]

James Thomson, breaking free from Pope's treatment of nature, though author of *Rule, Britannia,* virtually shuts out politics from *The Seasons.* He indulges, instead, in sublimity. But the important sublimity of his poem is not so much its "terrific" descriptions as its form-denying form. By definition the sublime is formless, and the incoherence of *The Seasons* reveals the penetration of sublimity past subject matter into structure.[22] The effect was admirably defined by Dr. Johnson: "The great defect of *The Seasons* is want of method; but for this I know not that there was any remedy. Of many appearances subsisting all at once, no rule can be given why one should be mentioned before another; yet the memory wants the help of order, and the curiosity is not excited by suspense or expectation."[23] Thomson's arrangements, from his syntax to his choice of where to enter the seasonal cycle, are to a surprising degree arbitrary. There is no reason why we should begin with *Winter* rather than *Spring:* the four poems were not published in the order in which they finally appeared together.[24] *Summer* is built upon the progress of a day from sunrise until night, but even that coherence is disrupted by the poet's shifting of his scenes from

21. John Barrell, *The Idea of Landscape and the Sense of Place 1730-1840* (Cambridge, 1972), repeatedly stresses the "hostility" and "aggressive dominance" of eighteenth-century landscape poets—on Thomson, see pp. 24-25. Barrell, incidentally, feels that Thomson's language and syntax prove his dependence on the models of painters such as Claude, who gave the poem "an *a priori* conception of the structure of landscape" (p. 161).

22. For another view, see Patricia M. Spacks, *The Poetry of Vision* (Cambridge, Mass., 1967), esp. pp. 13-45. Mrs. Spacks and I agree as to the descriptiveness of the poem, but the divergence in our evaluations is illustrated by our comments on Thomson's science—see her pp. 33-37. We are equally indebted, however, to Alan Dugald McKillop's pioneering *The Background of Thomson's "Seasons"* (Minneapolis, 1942). The most favorable critique of recent years is Ralph Cohen's *The Unfolding of "The Seasons"* (London, 1970), following his monumental *The Art of Discrimination* (London, 1964). Fascinated as I am by Professor Cohen's analyses, I cannot accept his claim for *The Seasons'* absolute excellence as poetry. Cohen, however, has studied the poem longer and more intensively than anyone else.

23. Samuel Johnson, *Lives of the English Poets,* ed. G. B. Hill, 3 vols. (London, 1963), 3: 299-300.

24. *Winter* appeared in 1726, *Summer* in 1727, *Spring* in 1728, and *Autumn* as part of the first collected *Seasons* in 1730. All my quotations from the poem are from *The Complete Poetical Works of James Thomson,* ed. J. Logie Robertson (1908; London, 1951).

one part of the world to another. Yet, as Johnson says, there is no remedy, because Thomson's subject is "many appearances subsisting all at once." His subject is all of nature. Selectivity is antithetical to his central purpose. He thus focuses a problem in all landscape art: any natural scene is an infinite number of appearances subsisting all at once. Any selection falsifies nature; any conceptual scheme of choice works against our subliminal sense of nature as a total continuum. The significance of the natural world seems inseparable from its totality and its total interconnectedness. Wisely or foolishly, Thomson desires to attain that effect in his poem, trying to reach it through impersonality. In portraying reactions to the appearance of a comet, he reveals the nature of what he calls his "philosophic eye," the mode of vision favored throughout *The Seasons.*[25]

> But, above
> Those superstitious horrors that enslave
> The fond sequacious herd, to mystic faith
> And blind amazement prone, the enlightened few,
> Whose godlike minds philosophy exalts,
> The glorious stranger hail. . . .
>
>
>
> In seeming terror clad, but kindly bent
> To work the will of all-sustaining love—
> From his huge vapoury train perhaps to shake
> Reviving moisture on the numerous orbs
> Through which his long ellipsis winds, perhaps
> To lend new fuel to declining suns,
> To light up worlds, and feed the eternal fire.
> (*Summer,* ll. 1711–29)

At the end of the century William Blake attacked this kind of scientism as a disguise for blind faith.[26] Thomson's assurance that the

25. Marjorie Hope Nicolson, *Science and Imagination* (Ithaca, 1956), pp. 210–11, observes that Thomson was perhaps only comfortable with superficial vision: in *Summer,* lines 287–317, he expresses revulsion at the fecundity of nature revealed by the microscope.

26. Blake, so far as I know, does not specifically criticize Thomson, but his condemnations of Deism apply perfectly to *The Seasons.* Mrs. Spacks defends the passage: "The diversity of subject and language reveals alternative ways for perceiving the same phenomena and insists that the poet can unite different ways of perceiving through his awareness of universal pattern" (*Poetry of Vision,* p. 34). But this is not consistent with the assertion four pages later: "This is Thomson's spirit throughout *The Seasons:* scientific in its desire to "see" and understand the workings of

comet is benevolent exemplifies the self-deception Blake condemned. The comet may bring moisture, or it may bring fire, but it must, somehow, bring good. Blake ridiculed the wisdom of such explanations as less worthy than the honest superstitiousness Thomson scorned. In Blake's view, the irrationality of a Thomsonian system is evidence that its one valid basis is not, as Thomson thought, reason, but what Blake called imagination. To Blake, *The Seasons,* so far as it is a poetic work at all, must occasionally erupt into something beyond rational order, into sublimity, because only then does Thomson's self-deluding system fail.

A Blakean diagnosis returns us to the shrewdness of Dr. Johnson's comment, "The great defect of *The Seasons* is want of method." The poem seems full of method, yet inspection shows Thomson less systematic than impersonal. He is not inept; he tries to impersonalize the poem. His sentimental stories are presented with relative objectivity. He uses the pathetic fallacy sparingly, often subordinating even personification to more formalized patterns, such as that of polysyllabic modifier and monosyllabic substantive (thereby disjoining linguistic form and semantic content): "gentler mood," "mournful grove," "waving air," "rising gale." All these traits point up Thomson's determination not to participate interactively with the phenomena which are his subject. He might have attained more articulated coherence had he worked experientially rather than descriptively. Experience, at any rate, is the method used by Romantic poets to organize their explorations of the natural world. Because Wordsworth's relation to nature is interactive instead of observational, his poetry is not simply more subjective than Thomson's but also conveys the impression of being truer to nature. To "experience" means to "meet with," to "feel," to "undergo," to "learn," to "find," and, perhaps most significantly, to "put to the test." Romantic stress on experience is misunderstood if treated only as exploitation of subjectivity. It is a way to better understanding of the objective universe. By concentrating on a specific experience the Romantic penetrates into the workings of phenomena (contrast Thomson's surveys) and grasps what connects phenomenon to phenomenon, learning principles of *relation.*

natural force, reverent in its recognition that it is finally impossible to understand." What happened to the universal pattern?

Of these principles none is more important than time. Although *The Seasons* is about time, Dr. Johnson astutely observed that the poem provides neither assistance to memory nor encouragement to expectation. Today we tend to look for, and be disappointed by the absence of, intricate temporal involutions, which Romantic and post-Romantic poetry has conditioned us to expect. But Thomson is reluctant to treat the same place more than once, just as he avoids repetition of words and phrases. He cannot, therefore, represent involutions in time. Both substantively and linguistically *The Seasons* is unmemorable because it offers nothing to which one can return. It is true, however, that time advances irreversibly. The texture of, say, Wordsworth's poetry derives from his emphasis upon personal memory, deliberate distortion, one might call it, of time. And Wordsworth could scarcely have distorted so meaningfully without Thomson's earlier rendering of what is distorted, the natural time to which Wordsworthian psychology gives texture. Thomson's poem portrays, to the virtual exclusion of all else, natural change. So far as there is effective method in *The Seasons*, it serves to increase our awareness of natural transformations. A gross illustration is the form of each season's progress from beginning to culmination. More important is that most of Thomson's descriptions are of weather—and weather changes. Thomson's landscapes are original because in them the focus shifts from fixed objects constituting the *form* of a scene toward the meteorological phenomena which give the scene its quality or tone as an *event*. Each of Thomson's seasons is an event.

> Thence expanding far,
> The huge dusk gradual swallows up the plain:
> Vanish the woods: the dim-seen river seems,
> Sullen and slow, to roll the misty wave.
> Even in the height of noon oppressed, the sun
> Sheds, weak and blunt, his wide-refracted ray;
> Whence glaring oft, with many a broadened orb,
> He frights the nations. Indistinct on earth,
> Seen through the turbid air, beyond the life
> Objects appear, and, wildered, o'er the waste
> The shepherd stalks gigantic; till at last,
> Wreathed dun around, in deeper circles still
> Successive closing, sits the general fog

> Unbounded o'er the world, and, mingling thick,
> A formless grey confusion covers all.
> *(Autumn,* ll. 717–31)

I know of no prototype for this representation of indistinctness, of a landscape interesting because progressively less visible. Here the "horrid, vast sublime" of distant objects flows down, as it were, into the immediate environment, becomes almost a tactile presence, and, thereby, available as part of the mode of perception instead of merely what is perceived.

A landscape painter is handicapped by his medium in representing change. Poetry is better suited to depicting landscape as transformation, and Thomson is the first to take advantage of the unique possibilities of poetic landscape art. Yet Thomson, though he rarely imitates particular paintings, could not have written as he did had he not been taught by painters to see landscape artistically. His debt is suggested by his famous line:

> Whate'er Lorrain light-touched with softening hue,
> Or Savage Rosa dashed, or learned Poussin drew.

Thomson, in fact, conceives of natural scenes only in terms of visualization.[27] But whatever his dependence upon graphic artists, Thomson's *Seasons* is a major aesthetic turning point, establishing the possibility of new relations both between man and the natural world and between the sister arts. For example, he makes feasible significant poetic influence upon landscape painting, as is shown by Turner's and Constable's repeated use of his poem. *The Seasons,* whatever its artistic inadequacies, prepares the way for new kinds of interaction between artists and natural phenomena, such interactions creating the potentiality for emergence of newly dynamic and complex relations of audience to aesthetic artefacts.

These potentialities are first realized in Wordsworth's vision from

27. Which landscape pictures Thomson may have seen is difficult to determine. Still the best general treatment of the topic is Elizabeth Manwaring, *Italian Landscape in Eighteenth-Century England* (London, 1925), but she has little to say on specific influences. Jeffrey Spencer (*Heroic Nature,* pp. 258–75) argues effectively for more direct influence upon Thomson than has been recognized of Brill, Elsheimer, and even Reni. See also William Hazlitt, "On Thomson and Cowper" (*Complete Works,* ed. P. P. Howe, 21 vols. [London, 1930–34], vol. 5), stressing particularly Thomson's attention to the "impression which the whole makes" (p. 87).

Mt. Snowdon in the final book of *The Prelude*. Wordsworth's description is of weather, specifically of clouds, but it is intensely localized (Wales, Snowdon, Bethkelet's huts) as Thomson's views never are, and it is introduced, again, as Thomson's views never are, by many *personal* particularities—enough to occupy the first twenty-nine lines of book 13. And the Snowdon episode is carefully placed as the climax of *The Prelude*. It could not appear elsewhere without disturbing the poem's meaning and without losing some of the effectiveness it derives from being the last of the poet's intense experiences in nature.[28] Snowdon climactically affirms the capability of imagination to identify man's place in nature, a position midway between the bright clarity of Heaven and that "dark, deep thoroughfare" through which mounts "the roar of waters" from hidden but "real Sea" and earth.[29] It is a position reached only after twelve books, only by a toilsome ascent ("that wild place and at the dead of night"), a lengthy journey sustained by excited aspiration, "I panted up/ With eager pace, and no less eager thoughts," even though the poet's ambition—to see the sun rise—is wiped out by the unexpected vision of the moon shining upon the clouds. Such supervening of unanticipated natural event upon nature's predictable patterning occurs in no earlier landscape poem. And the sequence of excursion checked by unexpected force, the halting of the poet's progress initiating a psychic measuring back of his journey, leading to a richer reintegration of his mind with the natural world—this process of advance, halt, reintegration, *is* the process of mental growth, imaginative development.

For Wordsworth, each imaginative act changes the unity of the

28. Though placed last, even in the early five-book version of *The Prelude*, Wordsworth's climb actually occurred *before* many of the other episodes recorded in the poem. This guileful chronological falsification is evidence of *The Prelude*'s structural complexity vis-à-vis *The Seasons*. Though John Barrell, *The Idea of Landscape*, rightly emphasizes how different from Wordsworth's sense of place John Clare's was, many of his comments on Clare in his long chapter (pp. 98–188) are helpful to an understanding of any Romantic landscape art.

29. Marjorie Hope Nicolson defines the irony involved in Romantics' representations of nature's vastness: "As we descend to earth with the Muse of the new poetry, our immediate impression is that it has grown immensely in magnitude and in size of natural objects—ironically enough, in view of the extent to which our planet has shrunk into comparative insignificance as a result of the new astronomy" (*Mountain Gloom and Mountain Glory* [Ithaca, 1959], pp. 331–32). And Miss Nicolson later suggests how this ironical situation arose: "The poets . . . are *involved* in Nature. Mountains and ocean, like the sweep of indefinite time or the sense of infinite space, are shadows of divinity" (p. 382, my italics).

imaginer's life, transforming the quality of his life history into rich-
er self-integration. Wordsworth's imaginative perceptions improve
his fashion of perceiving. They are, then, nourishment, as is ingest-
ed food, for continuing development. The parallel, suggested by
the poet's frequent association of images of eating and drinking
with descriptions of imagination, can be pushed farther. One may
choose to nourish one's body properly, but the processes of assim-
ilation and consequent growth are motor activities, beyond the
control of will. Digestion and imaginative development alike re-
quire passivity. The poet may choose a healthy environment, but
he cannot choose to have an imaginative experience. He cannot
control his growth. Hence, as in the Snowdon episode, the critical
events in the poet's life, acts precipitating imaginative enrichment,
take him by surprise. The opportunity to advance manifests itself
as an apparent halt.

The pattern recurs throughout *The Prelude*, not only in special
episodes—meeting the discharged soldier, crossing the Alps—and not
only in more encompassing organizations—the check to Wordsworth's
idealism administered by the transformation of revolutionary ideal-
ism into Robespierre's Terror—but also in the structure of the poem
as a whole. Books 2-13 render the large act of growth that is
Wordsworth's coming to maturity as a poet resulting from the halt
presented in book 1 as his inability to find means to exercise his
liberty. This macrostructure accords with the process of growth
being recognizable only after the fact. We notice our children are
growing taller only after they have grown taller. So the Snowdon
episode is followed by meditation, Wordsworth recognizing his
growth, or affirming the event's importance by recognizing its im-
portance.

A Wordsworthian landscape is inseparable from the history of the
poet's mind. Much of his best verse concerns unimportant incidents
which become significant when, subsequently, Wordsworth per-
ceives them to have been decisive to his maturation. Without the
poet's self-consciousness the events would remain trivial. Even a
spectacular scene, such as the view from Snowdon, would be super-
ficially sensational, a piece of Thomsonian sublimity, were it not
means through which the poet becomes aware of enhancement of
his imaginative power. Here history in the mode of reflexive con-
sciousness enters into poetic landscape as a genuine equivalent of

the painter's chiaroscuro. The equivalency is manifested in Words-
worth's escape from visualization into a more appropriately *poetic*
rendering of landscape, one intrinsically synaesthetic.

The grandeur of what the poet sees from the mountain is created
as much by sound as by sight. Wordsworth effectively embodies
the indescribable (not capable of being written down) sublime by
dramatizing an interaction between visual and auditory phenomena.
In the context of the entire *Prelude*—and the episode's meaning de-
pends on this context—the roar of waters is what the "murmur" of
the "sweet stream" of lines 13–14 in book 1 has become—a sound
filling all the space between sky and earth. It was for *this*

> That one, the fairest of all Rivers, lov'd
> To blend his murmurs with my Nurse's song,
> And from his alder shades and rocky falls,
> And from his fords and shallows, sent a voice
> That flow'd along my dreams.
> (bk. 1, ll. 272–76)[30]

Even the visual contrasts of light against dark are deepened by the
poet's juxtapositions of invisible and visible. Furthermore, the
bright, clear firmament is silent—the light of heaven, unlike earth's
life, is noiseless, although traditionally divinity is associated with
thunderous sound from on high. From beneath the poet rises a
harmonious roar of waters, the sound of earthly nature. Words-
worth's vision is of the brilliantly visible, yet silently inscrutable,
beauty of the heavens encountering the dark, invisible beauty of
nature's liquid voice, the vital noise of earthly being. The vision is
an interpenetrating of invisible sounds and visible silences, the poet,
the reflexively conscious visionary, being not a mere observer or re-
cipient but the synaesthetic creator of the interpenetration's mean-
ing. It is the poet who unifies what without his human conscious-
ness would be only binary oppositions of sound-silence, light-dark-
ness.

But the poet is a specific person with a particular history. The
Snowdon passage records a unique, actual event, a fusion of sight
and sound Wordsworth created one summer night in 1791. The
poetry finds meaning in an unrepeatable confluence of natural ap-

30. Quotations from *The Prelude* are from the 1805 text of Ernest de Selincourt, 2nd
ed., rev. Helen Darbishire (London, 1959). For contrastive divine thunder familiar to
Wordsworth, see Psalm 77: 16–19, and of course the Book of Revelation.

pearances in singular engagement with the poet's psyche. A reader of the Snowdon passage, therefore, encounters a peculiar event and, like the poet in his unexpected meeting with special contingencies of natural process, will find meaning in the poet's vision if he can respond with reflexive awareness to the verbal dramatization as a historical event. The reader is not asked merely to imagine a scene; the power of visualization required for response to Thomson's temporal but not historical landscapes is inadequate in *The Prelude*. The Snowdon episode climaxes an autobiography (something quite different from an impersonal, unlocalized Thomsonian survey) and invites the reader to assume a relation to the poem which is that of a historian.

The only external world he has to deal with is the records. He can indeed look at the records as often as he likes, and he can get dozens of others to look at them: and some things, some "facts" can in this way be established and agreed upon. . . . But the meaning and significance of this fact cannot be thus agreed upon, because the series of events in which it has a place cannot be enacted again and again. . . . The historian has to judge the significance of a series of events from the one single performance, never to be repeated, and never, since the records are incomplete and imperfect, capable of being fully known or fully affirmed. Thus into the imagined facts and their meaning there enters the personal equation. . . . The actual event contributes something to the imagined picture; but the mind that holds the imagined picture always contributes something too.[31]

To the single performance that is the Snowdon episode the reader should contribute something, above all consciousness that he "perceives" an "imagined picture." The art of earlier poetic landscapists had not been capable of making that call upon their readers' minds. One need not document with numerous quotations Wordsworth's awareness that upon the reader of *his* poetry (his "records") specially creative demands were made. Even in so early and simple a poem as *Simon Lee*, for example, the reader is explicitly challenged to "make" a "tale" of the "incident" recorded, a singular encounter with an old huntsman precipitating a poem of reflection upon the occurrence. The structure of the Snowdon passage, although subtler and more complex, is analogous, and works to the same end, encouraging the reader to respond actively, that is, to become aware of his creative

31. Carl L. Becker, "What Are Historical Facts?" in *The Philosophy of History in Our Time*, ed. Hans Meyerhoff (Garden City, 1959), p. 132 (originally in *The Western Political Quarterly* 8 [1955]: 327–40).

responsiveness. The obvious device for attaining this end is the sequence of description-meditation. We are given *both* the poet's experience of unique phenomenal circumstances *and* his mind's engagement with memory of the event. We are presented with the *significance* of the encounter created by the poet's reflection upon its effect on his mind, and we are thereby invited to undertake a self-confrontation analogous to the poet's, to reflect upon our experience of the poetic landscape we have been enabled to imagine.

Wordsworth's landscape carries a reader toward the position of historian depicted by Becker, one taking account both of the contribution of the "actual event" and the "mind that holds the imagined picture" of the event. In such historicity, as I have suggested, lies the final importance of the Snowdon landscape as the climax of *The Prelude.* The passage does not accommodate actualities of a unique occurrence and a unique life-history to any predetermined, or traditionalized, pattern of meaning. Here landscape ceases to be mere object of description, as it was even for Thomson, though he had moved beyond the conceptual limits implicit in generic decorums employed by Denham and Pope. With *The Prelude* poetic landscape becomes means for the poet to transcend the Aristotelian distinction between poet and historian, to make history out of nature.

6

The Leaping Horse and
Home at Grasmere

Having contrasted Romantic landscape art with what preceded it, I want now to suggest how the nature in and the nature of Romantic landscape art differs from what follows it. Some consideration of the personalities, and personal idealisms, of Constable and Wordsworth will help to focus the distinction.

John Constable was unsuccessful. Not a failure, not embittered, steadfast in the practice of his art, unstintingly supported by his family, he won only grudging recognition from critics, and never attained that serenity which is the prize of artists who feel, whatever others may think, that they have accomplished the tasks which lured them into art.[1] Constable's personality was perhaps less attractive than admirable: honest, firm in his convictions, persevering in all he

1. After 1820 many of Constable's pictures received praise from reviewers of exhibitions, some of it perceptive, but some of it exasperating to the painter, e.g., the remark by a reviewer for the *European Magazine:* "When his pictures receive the mellowing tint of time they will be inestimable." From 1830 to 1834 the influential *Morning Chronicle,* followed by the less important *Observer,* continuously attacked Constable. But it was less hostility than ignorance and indifference from which he suffered. See William T. Whitley, *Art in England, 1821–1837* (New York, 1930), for an excellent survey of reviews and judicious estimate of Constable's situation.

undertook, commonsensical and shrewd, never self-pitying. His comments about fellow artists and their works are never eccentric or malicious, though they reveal a satiric eye for cant and modishness, and a sardonic, even mordant bent of mind. Constable appears to have been unpretentious but tough, down-to-earth yet quietly idealistic. But something dark—not sadness, more akin to frustration—tinges his happiest painting. William Blake, like Constable in rugged masculinity of character, was a failure in a sense that Constable was not. But Blake achieved happiness; there is ebullience even in his spiteful personal satires. Blake, I believe, regarded himself as successful.

Blake had the advantage of being thought mad by his stuffier contemporaries. He did have visions. Always open to him were imaginative realms most of us never experience. Constable suffered under the disadvantage of being manifestly sane, no easy burden for an artist, as is suggested by his exchange with Blake (reported by Leslie).

The amiable but eccentric Blake, looking through one of Constable's sketch books, said of a beautiful drawing of an avenue of fir trees on Hampstead Heath, "Why, this is not drawing, but *inspiration*," and he replied, "I never knew it before; I meant it for drawing."[2]

Constable's retort is appealing in its levelheadedness and poignant in its implication: the man who said he never saw an ugly thing in his life seldom knew the refuge of inspiration. He was bound to the rigorous task of representing correctly a world outside him. For him the transforming imagination had to remain true to exterior phenomena over which he had no control. There is in his art an unusual tension, epitomized in his self-description as a natural painter. No one was more aware than Constable of the contradiction in that epithet, of the difference, for example, between colors in nature and colors on canvas. "So difficult," he said, "is it to be natural," in seven words summing up the central issue of E. H. Gombrich's brilliant *Art and Illusion*. Constable is interesting, finally, not because

2. C. R. Leslie, *Memoirs of the Life of John Constable,* ed. Jonathan Mayne (London, 1951), p. 280. I should point out that neither Leslie's nor Beckett's transcriptions of what Constable wrote are entirely reliable. I am grateful to Professor James Heffernan at Dartmouth College for alerting me to some rather spectacular textual problems and to Mr. Leslie Parris at the Tate Gallery for assistance on a particular crux. The forthcoming volume of correspondence and other papers, being prepared by Mr. Parris and his colleagues, should go far toward solving the textual problem, which exists, one hastens to add, only because of the devoted and indispensable editorial labors of Leslie and Beckett.

he provides a harmonized vision of man in nature but because he
was too honest to evade his intuition of an antagonism between man
and the rest of the natural world. He could not, like Blake, subsume
one realm within the other.

The Leaping Horse illuminates the ambiguity of Constable's vision.
The picture is not, to my mind, fully successful, and it happens that
we have several studies for the final version—or, better, versions—
demonstrating how difficult it was for him to be a "natural painter."
The basic features of the composition were present in his mind from
the first. The studies show Constable adding and subtracting little
but shifting arrangements almost restlessly. The gnarled tree in the
foreground, the horse, the boat, and the tall trees behind, even the
negative feature of the flatlands in the background (suggested I
think by pictures such as Rubens's *Chateau de Steen*) appear in
chalk and wash sketches in the British Museum, a small oil sketch,
a large oil sketch, and in two finished paintings.[3] The angle of vision
in all of these is virtually the same, but the relative positioning of
the elements is shifted. The foreground tree, for example, is to the
right of the horse in chalk sketches, behind the horse in a small oil,
to the right in the large oil sketch, behind in the final painting, and
in the subsequent variant is moved to the right once more. In one
of the chalk sketches and in the small oil the horse does not leap
but stands (in the variant it becomes a standing team). The prob-
lem of the boat, which in the large sketch follows one chalk draw-
ing in showing a boatman poling, is solved in the final painting
by addition of a sail. These manipulations indicate, I think, that
Constable struggled to portray a scene unobtrusively dramatizing
an antagonistic interplay of natural and human forces.

Simultaneously, he is conscious of his own power, the painter's
force. His relation to his subject matter is far from passive. He
does not copy or imitate—he shapes. Yet he is not impression-
istic; for him, painting is truly interaction with nature. Constable
wanted to do justice to both art and nature. That, he thought,
meant his paintings would never be popular (that is, favored by
connoisseurs), "for they have no *handling*. But I do not see *han-
dling* in nature." Yet subsequent critics have been interested in
his distinctive handling. The flecks of white paint he spattered on
his later pictures, "Constable's snow," as irritated contemporaries

3. It is probably impossible, as Lord Clark has implied, to ascertain the exact order
of all the studies. Mayne's edition of Leslie's *Memoirs* includes a reproduction of the
variant.

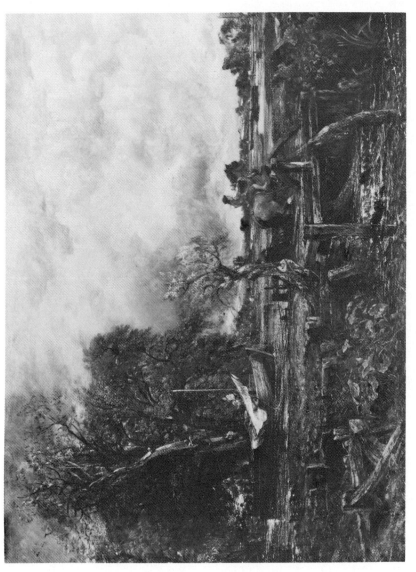

Constable, *The Leaping Horse*. (Reproduced by courtesy of the Royal Academy of Arts, London.)

called it, not only represent the sparkle and dewiness of a fresh atmosphere but also emphasize the paintedness of his pictures. For Constable this is the crux: how to balance conflicting truths of nature and art. Lawrence Gowing approvingly quotes a critic's observation in the 1820s: "It is evident that Mr. Constable's landscapes are like nature; it is still more evident that they are like paint."[4] Important in the remark is the parallelism. Constable does justice to both nature and paint.

Perhaps Constable's painting might be compared to farming, which is a shaping of the natural world. A farmer who does not understand nature will plant crops in poor soil, pasture sheep in the wrong field, generally will not get the most out of land, animals, and plants. But to make nature work to his advantage, the farmer must be aggressive, must rearrange natural patterns. Constable, analogously, is true to nature in order to reshape it. The various versions of *The Leaping Horse* show him maneuvering the phenomena which are his subject to realize some mental scheme, not a chance falling out of events. Yet he is not arbitrary. His originality lies in rejecting conventional artistic schemes (the sublime, the picturesque, and so on) while refusing merely to copy natural appearances.[5] His psychic patterns and nature's physical patterns, "in here" and "out there," must be made to *fit*.

4. Quoted by Lawrence Gowing in his stimulating *Turner: Imagination and Reality* (New York, 1966), p. 10. See also Conan Shields and Leslie Parris, *John Constable* (London, 1969), p. 6, on Constable's *trompe l'oeil* signature to *Flatford Mill*.

5. Because, as Gombrich has so brilliantly demonstrated, all artists depend on schemata, Constable, determined to represent nature accurately, was in a peculiarly ambiguous position, the position which makes his work the recurrent reference point for Gombrich's developing exposition throughout *Art and Illusion*, 3rd ed. (London, 1968). See especially pp. 149–52, viz., "Nearly all of his utterances betray this ambivalence toward tradition," p. 149. Despite his readiness to acknowledge his indebtednesses, Constable is often vehement in denouncing landscape conventions. "I looked on *pictures* as things to be *avoided*. Connoisseurs looked on them as things to be imitated, & this too was a deference . . . amounting to total prostration of mind & original feeling that must obliterate all future attempts—and serve only to fill the world with abortions." Constable's fierceness is partly explained by the keenness with which he felt the imperfection of his own accomplishment: "my 'light'—my 'dews' my 'breezes'—my *bloom* and my *freshness*—no one of which qualities has yet been perfected on the canvas of any painter in this world." Both quotations are from a letter to Leslie of 13 February 1833, *Correspondence*, 3: 94, 96. On Constable's manipulations of elements in *The Leaping Horse*, see Graham Reynolds, *Catalogue of the Constable Collection in the Victoria and Albert Museum* (London, 1959), especially p. 172, where he suggests there were originally two trees. C. S. Holmes, *Constable and His Influence on Landscape Painting* (London, 1902), provides a valuable discussion of the picture's genesis.

Such fitting is difficult. Turner, who, like Constable, tried to re-shape nature by developing a penetrating understanding of nature's inmost truth, was more successful in doing justice to both nature and art because he more daringly revolutionized painting techniques. Constable, technically more conservative than Turner, was also more divided in his allegiances. Turner, a Cockney, was pessimistic about man's destiny: he tirelessly reiterated the theme of his long poem, *The Fallacies of Hope.* Yet he never seems to have doubted that na-ture ought to be conquered by art, that art should be superior to nature. Constable, more a countryman, was ambivalent. Dubious that assertions of man's will against nature could succeed, he seems also to have been unsure that they should succeed.

The simplest explanation of Constable's dilemma is to interpret his rural scenes as a statement in favor of unspoiled English agrarian life. Yet, as Graham Reynolds has pointed out, most of his Stour scenes can be regarded as industrialized rural landscapes.[6] The point need not be exaggerated, but in *The Leaping Horse,* for example, our attention is drawn to the dam blocking the stream, the boat making use of the wind to navigate, and the man riding—in sum, to human control. Constable, to be sure, is no enthusiast for techno-logical industrialization; riding, sailing, milling are cooperations with the natural, not subjugations of it. Constable's affinities are to the farmer, not the industrial entrepreneur.

But whatever his affinities, Constable is a painter, and through his painting he brings himself into a rather aggressive relation to natural phenomena. The transpositions of *The Leaping Horse* are efforts by the painter to make himself, and through him the viewer of the picture, more than a passive spectator. Something analogous to the reflexive consciousness required by Wordsworth's Snowdon passage in *The Prelude* is called forth by *The Leaping Horse.* Our angle of vision is not frontal: that is, the main focus of our attention—the tall trees to our left, the boat, the canal, the gnarled tree, the leap-ing horse, the spillway—form a rectangular cell running diagonally to our viewpoint, not only from left to right and from front to back

6. Graham Reynolds, *Constable: The Natural Painter* (London, 1965), p. 16. Rey-nolds further observes: "almost every natural object seen by Constable . . . was the di-rect product of man's intervention with Nature. The trees cut back . . . the division of the land, its hedges, fences, lanes, even the course of the river were under his control. . . . Only the sky . . . was capricious" (p. 19).

but also from the height of the trees to the depth of the water below the spillway. This "cell" concentrates into small compass several contradictory vectors. The drift of the boat and the direction of the horse are countered by the prevailing twist of the foreground tree, while the water flowing through the spillway provides a contrasting back-to-front movement. This diagonal of counterthrusts dramatizes a more fundamental conflict, that between forces of horizontality and verticality. The dam, which supplies the flat roadway for the horse, is shown so that the verticality of its supports is emphasized. The flat water appears on two levels separated by the rise of the dam, the erectness of the boat's mast is crossed by the dropped sail on the spar, and the horizontality of the canal and background flatlands are interrupted by the trees and jumping horse. Of the interrupting verticals the foreground tree is compositionally more significant than the horse. The tree first catches the viewer's attention, and its shape and position embody the primary forces of the painting. Emerging from the dam which divides the two water levels, the tree epitomizes the obtrusiveness of all vertical forms in the painting. Its twisted agedness contrasts with the leap of the horse, as its new shoots, springing from a weather-wracked trunk, are another kind of temporal contrast with the full young trees behind the bared mast of the boat. The tender leaves of the gnarled stump dramatize the continuous transience of living things. The horse leaps, the boat drifts as the sail is furled, and the static trees appear not as objects but as growing and decaying organisms. Even the dam is less a finished artefact than an earth-and-timber body, pushing back against the inexorable pressure of the water, which penetrates it, and flows beyond and out of the picture. Overhead, clouds billow to create an almost oppressive sense of everchangingness.

Our view of all this is diagonal and directed toward the upjutting stump: a kinetic jolt between the verticality of time and the horizontality of timelessness. Greek architects sited their temples so that one's first and most telling view was of a corner, not full side or full front, horizontal and vertical being seen simultaneously and in kinetic conflict.[7] As the Greeks thus gave vitality to their stable temples, so Constable diminishes the stasis of his scene by jarring

7. See Vincent J. Scully, *The Earth, The Temple, and the Gods,* rev. ed. (New York, 1969).

our vision with the old tree, which, in terms of most conventional landscape schemes, is awkward, even disruptive. But his scheme counteracts a tendency of landscape foreground to fade into mere preparation for a deep perspective (one flaw in the variant). Forcing us to react immediately to the foreground tree writhing up against the strong horizontals in the picture (and as ironic reinforcement of the horse's leap), Constable involves us in a struggle between time and timelessness.

The effort to engage us in the dynamics of an apparently static situation distinguishes Constable's art from that of earlier picturesque and genre painters, even though he owes much to them in both subject and manner. In his painting, but not theirs, temporal contrasts play a subtle but crucial role by giving significance to what seem casual representations of random conjunctions of trivial objects. In *The Leaping Horse* a horse jumping in front of a boat focuses the antagonism between the never ceasing and the transient, between perpetual continuities and temporary phenomena. Even the contrast between the height of the near-background trees and the water flowing out below the dam visually reinforces the pervasive opposition in the picture between individuated phenomena and encompassing, enduring continuities. Engaged in this opposition are man's impulse to organize, control, and exploit nature, and nature's power to resist and eventually to overcome the impulse. The leap of the horse is necessarily instantaneous. The rider urges his mount up, but gravity will quickly pull both back to the horizontal pathway, which is, ironically, the top of a vertical dam.

Confrontation between temporarily rising verticals and enduring horizontals recurs throughout Constable's work, which characteristically represents the thrust of upright, individual forces (usually trees) out of a dissolving flatness of earth and water into skies which echo a fluid indeterminacy of the earth below. Because he depicts clouds with care and accuracy, Constable makes us feel the enigma of their ceaseless changefulness, the impersonality and delusiveness of their mobility, which seems almost to mock earth's organic forms. The potent, uprising shapes in the center of his pictures are curiously poignant—rather than impressive—because they appear between vast, atemporal continuities of watery earth and vapoury sky. This effect is in the painting of willows in a water meadow, which suggests Lawrence's "uninterrupted grass and a

hare sitting up." But Constable's image is richer than Lawrence's, for the old trees (like the gnarled stump in *The Leaping Horse*) are once again putting forth delicate new growths of spring. The power of Constable's watercolor *Old Sarum*, analogously, lies in its evocation of a city crumbled into the everlastingly receptive earth beneath a remote sky, the perpetual shifting of whose clouds becomes a context of enigmatic commentary on the transiency of objects below.

Constable is unwilling to surrender his allegiance either to the dimensionless continuity of the horizontal or to the transient specificness of the vertical. He loves the individuality of trees, yet he represents them within a broad, impersonalized context of earth and sky, whose flowing rivers and drifting clouds deny a tree's individuated significance. One reward for his refusal to choose is his success at conveying simultaneously a sense for both the endurance and the transiency of old trees and edifices. In his equal responsiveness to specific lives and to the continuum of natural life, and in his unostentatious assertion of his own individuality of spirit, his art, against the persistences of nature which it depicts, Constable reveals the depth of his rural heritage. An agriculturist does not merely accept what nature gives; he imposes upon nature his will, his scheme. Yet the agriculturist is aware of his dependence upon nature, and he is sensitized both to the continuities of natural existence and to the multiplicity of its temporary forms.

The end of the eighteenth century was a period in which, after millennia of triumphant agriculturalism, industrial civilization emerged. The Romantic epoch was agriculturally, as well as politically, a period of revolution and uncertainty. Constable recognized (given his Suffolk background the awareness is not surprising, for Suffolk, agriculturally progressive, suffered acutely in the post-Napoleonic agricultural depressions) that the basis of his civilization, the ultimate source of its value system, was being transformed. For Constable, as for other artists, the cultural moment at which he came of age was decisive.

The early nineteenth century was characterized by shiftings of the foundations of European culture. The deep shock waves intuited by John Constable in a quiet English countryside were sensed by other men in different situations. Because the movements were profound, they were inescapable, they were felt everywhere, and

sensitive men, especially artists, were not so much driven back up-
on their personal resources as troubled and made inquisitive about
the nature and origin of these resources. Questioning themselves as
well as their world, they came upon truths less available in more
stable eras.

Because for more than a century our society has been caught in a
flood of intensifying industrialization, only recently have we gained
enough perspective to appreciate the special quality of Romantic
intuitions, and to understand how different they are from our intui-
tions. For a long time Constable and Wordsworth have been
classed with later artists (even associated with artists of modern
times) who, whatever their accomplishments, lack their peculiar
quality of vision. I have tried to define something of that quality
by showing how Constable's success and failure is engaged to the
stresses of his age. I want now to show how Wordsworth's poetry
of nature, even though anticipating some modern conceptions, ex-
presses a sensibility alien to ours today.

I observed at the end of chapter 3 that Romantic *localization,* art
centered upon and controlled by depiction of place, was a key to
both graphic and poetic landscapes of the early nineteenth century.
In expanding upon that observation and validating it by analyzing
Wordsworth's *Home at Grasmere,* I risk obscuring an essential point
—that different Romantic artists liked different places and were fond
of them in diverse fashions. No one work can represent this variety.
Here the contrastive example of Constable's place will stand us in
good stead. And in one respect Wordsworth's preference is peculiar-
ly revealing of the Romantic sensibility. He does not always write
of beautiful, or even of remarkable, scenery. He describes many un-
spectacular locales and seems to favor unfecund ones. What most
attracts him, to use his own term, is a region, an interdependent,
self-sufficient place. Against the encroachments of industrial prog-
ress he defends not so much picturesque landscape as territorial
sanctuaries.

The poet, his family, and his friend Coleridge agreed that the
most complete expression of Wordsworth's philosophy was to be
The Recluse, a poem of which *The Excursion* constitutes only the
middle third, and to which *The Prelude* serves as introduction. Of
this proposed work only one book was composed, the lines known
as *Home at Grasmere,* published first nearly four decades after the

poet's death. But a few passages were printed during the poet's life-
time, and these are often cited as exemplary statements of his phi-
losophy. I suggest that *Home at Grasmere* is *The Recluse,* that
Wordsworth could never finish *The Recluse* because he had already
written it.

Home at Grasmere is a coherent work, and the truncation of *The
Recluse* to one book is formally appropriate to the poet's ambition.
The final lines proclaim the superiority of his theme to that of *Para-
dise Lost.* What could be more fitting than accomplishment of this
audacious purpose in one book instead of a dozen? At issue is not
so much length or brevity as a new kind of aesthetic unity. *Home
at Grasmere* coheres vertically rather than horizontally, the termi-
nology suggested by Wordsworth's emphasis on height-depth di-
mensions. Despite his concern with memory and time, he does not,
as one might expect, organize linearly. Characteristically he stands
at one spot and tells of different or reiterated impressions associated
with that place on diverse occasions. *The Ruined Cottage* and *Tin-
tern Abbey* are classic examples of this art of superimposition. Even
The Prelude, the total structure of which is circular, and *The Excur-
sion*—in more dramatic fashion, different speakers commenting on
the same scene or situation—reveal Wordsworth's inclination to
move through overlays and underlays of impression, speculation,
emotion. The wide-rangingness, or looseness, if one prefers, of his
style in poetic meditation is possible because it is rooted to a single,
fixed place. Thus the primary intrareferential system in *Home at
Grasmere* is literally and metaphorically vertical: the linking of
earth and sky is climactically imaged by the lake below reflecting
the heavenly dome—between which the swirling birds rise and fall.
The poet never moves, but his language falls and rises, most drama-
tically in the final "prospectus" lines, which repeat the structural
patterns of the opening lines on, simultaneously, both a higher and
a more profound level. Poetic form reproduces the "blended holi-
ness of earth and sky" the poet cherishes; the shape of the poem is
the shape of Grasmere Vale.

The unity of *Home at Grasmere* is inseparable from the topograph-
ical actuality of the valley, above all, its self-completeness. The val-
ley needs nothing because it is indivisibly self-unified.[8] The

8. "A Whole without dependence or defect,/ Made for itself; and happy in itself,/ Per-
fect Contentment, Unity entire," *The Poetical Works of William Wordsworth,* ed. Ernest

self-sufficing unity of being which the poet holds forth as a human ideal is naturalistically embodied in the form and condition of Grasmere Vale.

Wordsworth begins by referring to himself in the third person, as a "roving School-boy" when he first saw the valley years before. This characteristic gambit allows the poet to objectify his subjective experience, but then, with the confession of line 46, to transform the objective back into the subjective mode. The interchange establishes the poem's pattern, interplay between the poet's inner, imaginative life and his sensations of external realities in the circumambient vale. By beginning with his younger self, the poet introduces mnemonic dimensions into a poem focused on the present instant (in fact, though not calendrically, the first day of a new year), until it attains a climactic vision of the future. The high prophetic strain of the final lines is effective because developing from earlier interfusings of diverse time relations. From its first lines the poem demonstrates how awareness of time liberates man from the prison of immediacy, the delightful yet dangerous actuality of sensation and impulse.

This liberation entails no escape to some more idealized realm of being. Consciousness of time is alertness to the *continuity* of actual existence. Hence Wordsworth stresses the somatic component of memory. Memory functions most effectively, most creatively, in an ambience of reiterated impressions. Where the body can in some measure repeat its responses, the psychic power not merely to recollect but also to explore and enjoy mental connections between temporally distinct experiences is enhanced. Repetition is the locus for the experience of similitude in dissimilitude and the reverse, which in the 1800 Preface to the *Lyrical Ballads* the poet represents as essential to all human pleasures.

Wordsworth finds psychic freedom, then, within the restriction of a limited, familiar physical environment in which present sensations can be assimilated into an awareness of the flow of time. The same freedom appears in the final portion of the poem, where the present

de Selincourt, 2nd ed. (London, 1959), 5: 318, Appendix A, ll. 149–51. All references to Wordsworth's poetry in this chapter are to this edition, which prints what I call the "prospectus lines" (the last 107 lines) in their final form only in the Preface to *The Excursion,* ibid., pp. 3–6. At least part of the prospectus was composed as early as 1798, ibid., p. 372, and Mark Reed, *Wordsworth: A Chronology of the Early Years, 1770–1799* (Cambridge, Mass., 1967), p. 29, item 62.

is illuminated by an envisagement of future felicity—in the same place. Because past and future literally, corporeally as it were, exist in the present, recollective and visionary language both enter early into the poet's recording of immediate impressions. Paradise is not a place or condition beyond Grasmere Vale but its earthly actuality truly perceived. The contrast to Milton could not be more absolute. Wordsworth presents paradise by delineating the "little realities of life⁹" of an unimportant English valley whose most familiar inhabitants are a blind man, a paralytic, and a widow "withering in her loneliness."

The perfect spherical enclosure of the vale embodies the possibility of a wholeness of life, a joining of the psychic with the physical, of past with future in the present, which the innovations—economic, political, social—of the Napoleonic era in fact threatened, even though it originated within an ideal of such wholeness. Grasmere is no vacation spot, no mere place of respite from the fragmented restlessness of modern life. Nor is it a symbol of a utopian existence. It is an authentic alternative—because it is a real home.

The Wordsworthian home is the opposite of a Yeatsian ancestral house. The poet and his sister are newcomers to the vale. Grasmere is a place they *choose* to live in and to love. Home for Wordsworth is a limited territory, adopted deliberately as a self-sufficing physical environment, not an owned piece of property. The attractiveness to him of Grasmere is that it provides territory in which to roam, in which he can actively realize what is most vital in his being. What he does in Grasmere is to fit himself to nature, and fit nature to himself, not in the fashion of a farmer, a pastoral poet, or a modern exurbanite, but, strange as it sounds, in the fashion of a predator such as a wolf. I do not wish to press my animal analogy, but I know of no better way to define the poet's preferred relationship to nature, because it excludes conventional attitudes toward possession and property in its emphasis upon territorial familiarity. Wordsworth's attitude, if a lycanthropic comparison is too far-fetched, may be closest to that found in preagricultural societies, whose concepts of "land possession" are to us almost incomprehensible. Well-defined hunting territories among some American Indian tribes, for instance, do not constitute "communal ownership" as we, or the Soviets,

9. The quoted phrase is from the MS B version of the prospectus lines, *Poetical Works*, ed. De Selincourt, 5: 339.

understand the term. The relation between a preagricultural soci-
ety and its home territory usually, in fact, is too subtle, intimate,
and fluidly complex to be defined in the rigid, abstract terms of our
postagricultural possessiveness. Preagricultural peoples seem to feel
that they belong to their territory as fully as it belongs to them—
although such belonging is distinct from the enslavement of a serf
to a piece of land.

Wordsworth, however, desired no return to a primitive way of
life. He disliked hunting.[10] He claims simply that Grasmere Vale is
a perfect place to love. To define love in terms of territoriality,
emotional commitment to the unified complexity of a particular
geographical-econological entity, may be absurd. But it may also be
an aspect of what is called Romantic "organicism."

The vale "swarms with sensation, as with gleams of sunshine,/
Shadows of breezes, scents or sounds" and "solitude is not/ Where
these things are" (ll. 447–48 and 592–93).

> Society is here
> A true Community, a genuine frame
> Of many into one incorporate.
>
>
>
> Human and brute, possessors undisturbed
> Of this Recess, their legislative Hall,
> Their Temple, and their glorious Dwelling-place.
>
> (ll. 614–24)

Because man and nature can so interpenetrate in the vale, its "true
Community" must comprise "human and brute" and plant and topo-
graphic fact as well. The reality the poet praises surpasses "all Ar-
cadian dreams,/ All golden fancies of the golden age," (ll. 625–26),
because it entails man's involvement not with one segment of na-
ture but, instead, with a microcosmic reproduction of its wholeness.
The vale is a complete world in itself. Probably the most compel-
ling image of its living unity is that of the spiralling birds, rising
to the sky, dipping to the lake, engaged in an irregular dance be-

10. Wordsworth's distaste for the killing of animals with guns should not too
readily be attributed to sentimentality. Shooting birds and animals for sport with a
rifle, in fact, has nothing to do with the genuine hunting of most so-called primitive
peoples, which involves a participation in patterns of animal life. An excellent de-
scription of the hunting practices of a stone-age man will be found in Theodora Kroe-
ber, "The Hunter, Ishi," *The American Scholar* 31 (1962): 408–18.

yond the patterning of any human art, just as the scope of the birds' flight contrasts with the miniaturization intrinsic to all human art.[11] In their free yet vitally rhythmic activity the birds epitomize the liberating power latent in "this Recess," a literal hiding place of power.

Sensation "swarms" in Grasmere because, physically limited, it can be psychically familiar. Without familiarity the swarming of sensation would be unrecognized. What is merely a tree to the casual passerby, is to one familiar with it a tree planted by an old acquaintance. Our feelings toward a wild animal are likely to depend on whether or not we know its burrow. So the vale is enclosed not just physically but also psychologically. The poet loves it because he is intimate with both its "little realities" and it wholeness as a self-sufficient entity. Grasmere, then, is like the little world of a child. The analogy is encouraged by the poet's unabashed presentation of his relation to the valley as that of a child to its mother.

> Embrace me then, ye Hills, and close me in,
> . . . I feel
> Your guardianship; I take it to my heart;
>
>
>
> But I would call thee beautiful, for mild
> And soft, and gay, and beautiful thou art,
> Dear Valley, having in thy face a smile
> Though peaceful, full of gladness.
>
> (ll. 110–17)

The maternality of the vale is explicit, and much of the language of the poem works to feminize the landscape (even the sound of the words—note the liquidity of the sounds in the last line quoted) and to emphasize the poet's dependence. One need not interpret out a repressed psychic pattern. The poet proclaims his relation to the vale as sexual, even infantile, celebrating a conscious regressiveness. He does not uncover submerged, archetypal patterns and he disdains the support of concealed mythic significancies. He speaks for the pleasure of deliberately fitting oneself into a natural organization consciously discerned and appreciated. Indeed, what offends many twentieth-century readers of *Home at Grasmere* is its manifest

11. See chapter 4, note 3, above.

discursiveness, that is, the poet's attempt to deal rationally with topics we tend to feel ought not to be represented downrightly— topics such as the love of a brother for a sister.

Originally, references to Wordsworth's sister were disguised by the use of the name "Emma," usually "my Emma," but this subterfuge was dropped in revision, principally, I believe, because openness is essential to the poem.[12]

> On Nature's invitation do I come,
> By Reason sanctioned—
>
>
> Mine eyes did ne'er
> Fix on a lovely object, nor my mind
> Take pleasure in the midst of happy thoughts,
> But either She whom now I have, who now
> Divides with me this loved Abode, was there,
> Or not far off. Where'er my footsteps turned,
> Her Voice was like a hidden Bird that sang,
> The thought of her was like a flash of light,
> Or an *unseen* companionship, a breath,
> Or fragrance independent of the wind.
> (ll. 71–94)

I quote at length to illustrate that while it may be legitimate to describe Wordsworth's feeling as "incestuous," if "fraternal love" seems too feeble a term these days, it is less legitimate to claim that the poet is unaware of his "incestuous" feelings, that he inadvertently reveals repressed impulses. Whether or not one regards the poet's feelings toward his sister as too intense to be "normal," the important fact is that he treats openly a subject rarely so treated in poetry. As F. R. Leavis has observed: "Sex is virtually absent from Wordsworth's poetry. . . . [But] there are . . . no signs of morbid repression anywhere in Wordsworth's poetry. And his various prose remarks about love plainly come from a mind that is completely free from timidity or uneasiness."[13] Nowhere in *Home at Grasmere* is there praise of merely instinctual behavior in man, of undisciplined release of animalistic impulse. The sanction of reason is ever-present.

12. As in *Tintern Abbey*, Dorothy, the person most nearly Wordsworth's genetic double, also serves as another form of superimposition.

13. Leavis's discussion appeared originally in *Revaluation*, but my quotations are taken from the reprint of his essay appearing in Jack Davis's handy collection, *Discussions of William Wordsworth* (Boston, 1964), pp. 90–108.

And Wordsworth's consciousness of loving his sister both exempli-
fies and reinforces his larger affirmation of the value of conscious
love for nature.

Conscious love demands restraint, for it is disciplined affection.
It controls aggressiveness, produces quiet receptivity, even passive-
ness, willingness to let things happen without trying to arrange them,
without meddling. The poet does not feel that passivity (including
yielding himself to nature as to a maternal being) denigrates his
manhood, because to him loving is both giving and receiving. Unlike
sexual impulse, love requires surrender of the pleasure of mere ag-
gressiveness. The yielding up of a masculine assertiveness implicit
in his fraternal affection adumbrates the quality of the poet's love
for Grasmere Vale, which is a cathexis directed to the complex to-
tality of the life of the valley as a whole, and which depends upon
overcoming any impulse to violate it, so as to attain a creative as-
sertion. By giving himself up to the completeness of life in the vale,
the poet attains a unique expressive power.

> To me I feel
> That an internal brightness is vouchsafed
> That must not die, that must not pass away.
>
>
>
> Possessions have I that are solely mine,
> Something within which yet is shared by none.
> Not even the nearest to me and most dear,
> Something which power and effort may impart,
> I would impart it, I would spread it wide,
> Immortal in the world which is to come.
> (ll. 674–76, 686–91)

Through humble passivity the poet has nourished within himself a
potency exceeding that of warriors and statesmen. It is this power
which informs the "prospectus lines," wherein the poet represents
his theme as grander and more thrilling than that of his greatest pre-
decessors, even Milton's:

> All strength—all terror, single or in bands,
> That ever was put forth in personal form—
> Jehovah—with his thunder, and the choir
> Of shouting Angels, and the empyreal thrones—
> I pass them unalarmed.
> (*Prospectus*, ll. 31–35)

The audacity of the poet may be breathtaking, but the ambition to which it leads is even more astonishing.

> Paradise, and groves
> Elysian, Fortunate Fields—like those of old
> Sought in the Atlantic Main—why should they be
> A history only of departed things,
> A mere fiction of what never was?
> For the discerning intellect of Man,
> When wedded to this goodly universe
> In love and holy passion, shall find these
> A simple produce of the common day.
> —I, long before the blissful hour arrives,
> Would chant, in lonely peace, the spousal verse
> Of this great consummation:—and by words
> Which speak of nothing more than what we are.
> (*Prospectus,* ll. 47–59)

The "produce of the common day" and "nothing more than what we are"—out of these, nourished by the spirit of Grasmere Vale, the poet will achieve an art undreamed of by poets of the past. His confidence is founded in the earlier portion of the poem, in which he describes "How exquisitely the individual Mind/ . . . to the external World/ Is fitted:—and how exquisitely too . . . The external World is fitted to the Mind." Thanks to the ecological wholeness of the vale in which he consciously participates, he is able to envision "the creation . . . which they with blended might/ Accomplish."

Through the poet's submergence into the maternal embrace of the valley will come the flourishing of a unique power of Wordsworth's mind, a power which he believes can be "spread wide." The poem redefines the "individual self" and attributes to the self so redefined far more than personal significance: "joy in widest commonalty" spreads from "the individual Mind that keeps her own/ Inviolate retirement."

Insisting that a potent "self" is created through deliberate fitting of one's individuality to the external world and of the external world to one's mind, Wordsworth implicitly rejects any ambition to improve nature. If we were to regard life on our planet as an interplay of ecosystems constituting a vast ecological totality, we would recognize that particular improvements are not free, not independent of consequences throughout the complex of systems. We would then perceive civilization as healthiest when most adroitly

adapted to the necessities of the total framework of natural balances within which it must function. This is, in effect, Wordsworth's vision: no return to primitivism, but, instead, full utilization of trained consciousness so as to fit better with the unified interdependence which is nature.

The valley Wordsworth praises is not a primitive place, although it is not in the mainstream of the progressive agrarian-industrial society which was coming to dominate the life of Great Britain in his day. The primitive mind, one deduces from the poet's affirmations, is inadequate because it has not developed to the point where it can effectively work with the full requirements of ecological reality. Using Wordsworth's own terminology, one might say that the primitive mind can fit itself to the external world, but cannot fit the external world to the mind. Contrarily, the modern farmer, industrialist, or urbanite fits the world to his mind (usually with the aid of a bulldozer), but cannot fit his mind to the world. Both kinds of fitting are necessary. We now know of many human societies which have weakened, even destroyed, themselves through misuse of nature. Wordsworth would not be surprised. To him civilized life is the fulfillment of natural life, not its antithesis, just as the ultimate result of his submergence in the commonalty of Grasmere Vale is the realization of the power of his special, unique individuality. His individuality completes the natural self-sufficiency of Grasmere, reintegrating the natural and the human on a higher plane, or, more simply, transforming nature into paradise.

"Beauty . . . Surpassing the most fair ideal Forms" exists as the poet's "hourly neighbour" within Grasmere because in its actuality it *is* "Paradise, and groves/ Elysian, Fortunate Fields" since the poet's "discerning intellect" has been "wedded to this goodly Universe." What *Home at Grasmere* describes is the consummation of the union, the making of a microcosmic world. Wordsworth's relation to the valley, if my observations of children and my memory of my own childhood do not betray me, is very close to that by which a child fits himself to, and makes fit his demands, the microcosmic environment of a garden, a farm, or a country place. The child makes the limited environment into a self-sufficient world, that is, a unity in which place and self are mutually defining. The peculiar poignancy (captured perfectly by a phrase in *The Excursion,* "familiar with forgotten years") of one's memories of such

microcosms of early youth springs from the fact that *there* one si-
multaneously discovered both the external world and one's self—
one through the other.

Whether or not I am right about children, in *Home at Grasmere*
Wordsworth insists that his unique self is defined in terms of a
place, *his* territory. In the "prospectus" lines he describes the mind
of man as the "haunt" and main "region" of his song, and the meta-
phors are significant. He treats mind as a territory. In the final
lines of *Home at Grasmere* we recognize that the shape and charac-
ter of the valley mirrors the form of a creative mind—self-contained,
self-sufficient, profoundly at ease. Not only does the poem's form
reflect its meaning, but also its meaning images its form, which is a
linguistic realization of the loveliness of the vale.

Home at Grasmere praises the divinity of the world and gives joy-
ous thanksgiving for the goodness of actual life, internal and exter-
nal. The valley indubitably is Wordsworth's temple, his holy place.
Just as indubitably it is also his home, his "Dwelling Place." And
if it is reasonable to suspect angels of speaking matter-of-factly of
the Heaven they inhabit, one may forgive Wordsworth some prosiness.
Living in paradise, he lives by ordinary standards "idly." Because
the poet does not segregate home from holy place, the sacred from
the profane, because to him commonplace living can be divine, his
religiosity appears as a kind of indolence.

It is only by opening himself to the unified wholeness of life that
Wordsworth can attain wholeness of individuality; it is to the rich-
ness, the abundance, the overflowing fullness of life in Grasmere to
which he persistently recurs. And in so doing, he implicitly dero-
gates the conventional work ethic. Like Cowper, Beattie, Collins,
and Gray before him, Wordsworth celebrates a life of sensations and
sensibility which excludes purposeful industry—bluntly, of earning
a living. But by making Grasmere a microcosmic ideal world,
Wordsworth raises the indifference to industriousness of nature-
loving poets to a negation of work as we usually conceive it.[14]
Grasmere Vale is not, as I have pointed out, a place of respite, a

14. In *Coopers Hill*, one notes, labor is not dwelt upon and not specially praised
but is not treated condescendingly or with indifference, as it is by some later poets
practicing in the local poetry tradition. A phase of this tradition is discussed with per-
ception by Geoffrey Hartman in "Romantic Poetry and the Genius Loci," in *The Dis-
ciples of Criticism*, ed. Peter Demetz, Thomas Greene, and Lowry Nelson, Jr. (New
Haven, 1968), pp. 289-314.

vacation spot, for by definition a vacation is a segment of life determined by a work routine, and the valley is self-sufficient. In it the poet's life can be successful only because he does nothing useful in the conventional sense—except praise, worship, write poetry. Wordsworth worked hard at his verse, even suffering physical anguish in its composition, but he does not in *Home at Grasmere* (nor in any other poem) describe the making of poetry of praise as work.

Many of us complain that the "realities of life" are "cold . . . ready to betray . . . stinted in the measure of their grace." Wordsworth, happily withdrawn in Grasmere, thinks we, not the realities, are at fault. He is overwhelmed by the lavishness with which his life is enriched at every turn by the reality of a rather barren valley. His message is that our perverse commitment to aggressive work impoverishes us, as well as impoverishing the natural world. Being busy blinds us to the potentialities for fulfillment which surround us. We are sick because we are not at ease in the affluence available to us at the cost simply of being quiet. Yet Wordsworth has no ambition to eliminate labor, and he decries sensual self-indulgence and self-gratification. For all his passivity, he is convinced that it is his moral obligation to contribute to the well-being of mankind. By turning away, not alone from the madding din of urban life, but also from aggressive impulses within himself, the poet develops a power to "impart" (not impose) a gift of transcendent worth.

Of what the gift consists we may discern by attending to the poet's mode of bestowal, the form of his poetry. In the earlier parts of the poem Wordsworth most often addresses the valley and the creatures in it (employing the intimate "thou"), and in the latter part he addresses himself, his own mind and spirit, but until the "prospectus" lines his mode is exploratory. He speaks to the valley in order to relate fully to it, in order to participate in its life, and he talks to himself in order to realize his complete psychic capabilities. The "prospectus" lines are the reward for these explorations, an attaining of what before had been only potential. In the closing lines the poet asserts and expounds, but until then he repeats himself as if hesitant, qualifies affirmations, and often balances opposed possibilities. Through this tentativeness he achieves a special kind of rhetorical accuracy: the effect of a man literally talking to himself. Success in this rhetorical mode (beyond attention to how in fact one does meditate, which is not in the elegantly conventionalized

manner of Renaissance literary meditations) probably depends upon
recognition of the connection between language and the individual
self. Communication, as animals prove, is often effectual without
language. But the discovery and formulation of a self may be regard-
ed as a function of our ability to speak to ourselves. Wordsworth
uses language to explore relations between himself and the world and
to define through the relations the power within him which other-
wise would remain impotent. His attitude toward language is appar-
ent in his characteristically long sentences of loose syntactic struc-
ture, which permit development of thought, expansive treatment of
emotion, and—above all—a fluid interplaying of perceptual fact with
mental fancy.

 Wordsworth prefers similes to dramatic metaphors. The simpler
trope suits his aim of realizing what Coleridge called unity in mul-
teity, the harmonious interrelating of disparate elements whose dis-
parateness is cherished as much as their coherence. The open and
extended comparison, furthermore, suits the poet's interplaying of
description (presentation of immediate sensations) with past impres-
sions, possible future observations, and even purely imagined per-
ceptions. The obvious sign of the intermingling of sensory fact with
mental fancy is Wordsworth's fondness for the subjunctive and con-
ditional, e.g., "And if this/ Were otherwise" (ll. 648–49). When one
contrasts *Home at Grasmere* to poems in the *genius loci* or local
poetry traditions within which he worked, one notices that what
distinguishes Wordsworth is the extent and subtlety of his devices
for making his record of immediate sensations interact with the rep-
resentation of mental actions beyond perceptual responsiveness. The
first two lines juxtapose "*yon* steep barrier" with the remembered
vision to introduce the interplay of fact and fancy, developed in the
opening verse paragraph by the boy's remark to himself "if a thought
of dying . . . could intrude" and by the older poet's assertion that
the boy felt only "A fancy in the heart of what might be/ The lot
of Others," namely, an existence that "never could be his." This ex-
ploitation of language's power to evoke "the contrary to fact" in
the very presence of the fact itself (e.g., what *is*, "never could be")
is perhaps Wordsworth's most characteristic and significant poetic
device. In diverse fashions it is central to poems such as *Tintern
Abbey, Resolution and Independence, Peele Castle,* and the *Intima-
tions Ode,* but nowhere does he employ it with more skill than in
Home at Grasmere.

His skill is visible in the second verse paragraph, in which the poet blends the boy's actual sensations with his mental creations (ll. 25–35). And the "unfettered liberty" which the vale now provides him derives from its simultaneous encouragement of delight in his perceptions and in his power to remember both what he had perceived and had imagined and to envisage what he will perceive and imagine. Possession of this multiple power convinces the poet that we are wrong to regard "the realities of life" as "stinted in the measure of their grace." Realities, the obstinate facts of actuality, are what provoke mental activity, especially imaginativeness, and imaginativeness, as the Preface of 1800 had suggested, "colors," that is, transforms without distorting.

Because the vale as an entity permits the poet to experience the "unity entire" of an ecological "Whole without dependence or defect," his imagination is liberated rather than confined by the limitedness of Grasmere. He is not tempted to distort perceptual reality, to seek refuge either in solipsism or in Arcadian dreams, but, instead, is enabled to project visions, memories, speculations, evaluations upon perceptual realities as fulfillments of their actualness. Thus he affirms that the dwellers in the valley "require/ No benediction . . . For they are blest already" because "They who are dwellers in this holy place/ Must needs themselves be hallowed" (ll. 277–78). Yet the affirmation is balanced by the reservation: "Thus do we soothe ourselves, and when the thought/ Is pass'd we blame it not for having come" (ll. 290–91). And in subsequent lines he repeats the caution of lines 273–76 that he does not merely report perceptible reality, while demonstrating, as for example through references to the "reiterated whoop" of the shepherd, that he has not been "betrayed by tenderness of mind" into romanticizing the harsh truths of valley life. The shepherd's voice, "a Spirit of coming night," to "superstitious fancy" might seem "Awful as ever stray Demoniac uttered," and may "have reached mine ear/ Debased and under profanation." Man can make of perceptions something different from their "literal" truth (else there would be no "making"), yet if a man's spirit be properly attuned through his participation in the wholeness of life's unity, his "makings," his imaginations, will be neither falsifications nor evasions of actuality.

This brings us to the core of Wordsworth's ideal of what poetry should be and do.

> . . . is there not
> An art, a music, and a strain of words
> That shall be life, the acknowledged voice of life,
> Shall speak of what is done among the fields,
> Done truly there, or felt, of solid good
> And real evil, yet be sweet withal,
> More grateful, more harmonious than the breath,
> The idle breath of softest pipe attuned
> To pastoral fancies? Is there such a stream,
> Pure and unsullied, flowing from the heart
> With motions of true dignity and grace?
> Or must we seek that stream where Man is not?
> (ll. 401–12)

These interrogatives are finally transformed into the triumphant declaratives of the "prospectus lines," for this ideal of poetry is what *Home at Grasmere* proclaims. Poetry is language which, without falsifying literal actuality, will liberate man from the prison of perceptual responsiveness, enabling him to be simultaneously a sensitive and a creative soul, being one because he is the other.

Liberation depends upon conscious participation in the living yet nonperceptible *unity* of the vale, in its ecological equilibrium. Such conscious participation only language can carry us toward and give expression to when attained. Language distinguishes us from the so-called lower forms of life. Used poetically, language enables us to reintegrate ourselves with those lower forms (as well as with inanimate nature) without becoming imprisoned in sensory responsiveness, without becoming mere creatures of impulse. Animals inhabit environments apprehended almost entirely through immediate sensations; they do not appear to compare present with past perceptions nor to imagine how and why something perceived now might be different at another time or be responded to differently. Properly used, language permits us to do these things, and so live more richly and complexly the same life, the "one life," not only of animals but also of flowers, which, as we may imagine as they can not, "enjoy" the air they breathe. What Wordsworth imparts is the power language bestows on us consciously to reintegrate our lives into the affluence of natural existence and thereby to exalt man and nature, rather than debasing one before the other.

Whether or not one judges that Wordsworth's poetry successfully expresses the ideal of poetry articulated in *Home at Grasmere,* one cannot deny him an ecological conception. But contemporary

jargon should not mislead us. His aim in and manner of presenting his vision is foreign to our sense of how poetry ought to function. That on occasion the Romantics prophetically anticipate our ideas only makes more apparent that their sensibility is to us alien. I suggested in the first chapter that Wordsworthian and Freudian psychology are, in essentials, incompatible. My analyses have substantiated, I hope, the observation that the antagonism between modern and Romantic psychology rests upon antithetical cosmologies, the antithesis significantly determined by the special Romantic concern for a temporal continuity strange to our less historically oriented consciousness.

I conclude, therefore, by reaffirming my earlier observation: the nature in and the nature of Romantic art is obsolete. However we evaluate the configuration of competing alternatives the handbooks call Romanticism, for us it is an uncongenial point of view. If we insist on treating Romanticism as the beginning of the modern era, let us remember how long that era now has lasted, how far we stand from the origins of our civilization. This is the principal unity we find in the diversity of early nineteenth-century art: whatever Constable and Wordsworth may have shared, for us they are primarily though not exclusively linked by a common remoteness. However we may view the world today, we can no longer possess Romantic landscape vision. Therein lies both its irrelevance and its preciousness.

APPENDIX
INDEX

Appendix

Few readers can be more aware than I of the lack of comment in this book upon literary and pictorial landscape art in Britain during the half-century 1750–1800. This note, touching on only one aspect of the subject, may suggest why the epoch deserves more extensive examination than I could properly devote to it in this volume. It would be difficult, for example, to invent a contrast to Thomson's *Seasons* more striking than is provided by the *Ossian* poems of James Macpherson, published a generation after the appearance of Thomson's work. Since *Ossian* had influence all over Europe, it is worthwhile to consider the character of its representations of natural scenes and its use of imagery drawn from natural phenomena.

His words reached the heart of Clessammor; he fell, in silence, on his son. The host stood darkened around; no voice is on the plain. Night came, the moon, from the east, looked on the mournful field; but still they stood, like a silent grove that lifts its head on Gormal, when the loud winds are laid, and dark autumn is on the plain.

Three days they mourned above Carthon; on the fourth his father died. In the narrow plain of the rock they lie; a dim ghost defends their tomb. There

135

lovely Moina is often seen; when the sun-beam darts on the rock, and all around is dark. There she is seen, Malvina! but not like the daughters of the hill. Her robes are from the stranger's land; and she is still alone!

Fingal was sad for Carthon; he commanded his bards to mark the day, when shadowy autumn returned. And often did they mark the day and sing the hero's praise. "Who comes so dark from ocean's roar, like autumn's shadowy cloud? Death is trembling in his hand! his eyes are flames of fire! Who roars along dark Ora's heath? Who but Carthon, king of swords! The people fall! see how he strides, like the sullen ghost of Morven! But there he lies a goodly oak, which sudden blasts overturned! When shalt thou rise, Balclutha's joy? When, Carthon, shalt thou arise? Who comes so dark from ocean's roar, like autumn's shadowy cloud?[1]

The mistiness, vagueness, and darkness which I have credited Thomson with introducing into natural description becomes dominant—oppressively dominant—in *Ossian*. Macpherson extends outline-blurring from description into lyric lamentation, as in the last sentence of the quotation above. The extension is important, because the basic sequential pattern of the *Ossian* poems is that of relatively brief narration of action followed by lyrical comment upon the action. This pattern is congruent with Macpherson's temporal perspective. *Ossian* is entirely historical: even its fraudulence is as a historical document. *The Seasons,* contrarily, is descriptive, even to favoring the present tense. Yet Thomson often describes the passage of time, and, though one shrinks from calling his work protohistorical, it does not stand in the way of development of a more historical descriptiveness. Continued attention to the changes of nature, to the spectacle of physical transience, leads logically to melancholy, a persistent feeling of loss—the mood of Macpherson's poem.

If we admit *The Seasons* could provide a start for the dominating tone and perspective of Ossian, the contrast between the styles of the works becomes even more impressive. Briefly, Thomson avoids repetition, whereas Macpherson repeats relentlessly. Thomson's blank verse is founded upon complicated syntax; his long sentences are carefully, often intricately, articulated. Macpherson tends to avoid periodic sentences, preferring simple syntactic units. Inde-

1. The passage is from *Carthon,* a shorter poem in the *Fingal* volume, published in 1762. I quote, in order to draw attention to the anthology, from the text given by Ricardo Quintana and Alvin Whitley, *English Poetry of the Mid and Late Eighteenth Century* (New York, 1963), pp. 278–79, one of the most useful collections of poetry of this period.

pendent, even isolated, grammatical structures are the core of the
Ossianic style. This primitive manner is meant to reflect the primi-
tiveness of Macpherson's subjects, and should, I think, be associated
with a graphic style which flourished during the middle and late
years of the eighteenth century, what is sometimes called histori-
cism, a part of the style of linearism. Robert Rosenblum, comment-
ing on the origins and characteristics of this style, calls attention to
its "primitive austerity . . . in contrast to Rococo." He notes the
importance of the discovery of an early painting at Herculaneum:
"This picture with its clean geometric divisions and its simplified,
unbroken contours evoked a past that seemed to mark a virile begin-
ning rather than a decadent conclusion to a cycle of art and civiliza-
tion."

Macpherson was not consciously influenced by graphic histori-
cism; rather, *Ossian* is an independent literary expression of a simi-
lar antirococo impulse. When Rosenblum comments upon fascina-
tion with "the seemingly crude terribilità of the Greek Doric order
or the elementary pictorial means visible in the flattened spaces and
precise outlines of Greek vases and Italian primitive paintings," he
specifies qualities analogous to those cited in the later eighteenth
century by commentators praising *Ossian*. And their frequent com-
parison of the poem to Homeric epic is more comprehensible if we
see that the often-ridiculed primitivism of the epoch does include
significant aesthetic innovations.

In the Fall of Lucifer, a vertiginous cosmic descent is rendered through pictor-
ial means that almost prophesy Futurism. . . . Flaxman's symbolic equiva-
lents of motion may be . . . the first rejection of the perceptual illusions of
motion employed in the Renaissance and Baroque pictorial tradition.[2]

I am reluctant to claim that Macpherson's poem embodies an equiv-
alent challenge to previous literary techniques, or that it stands as an
equivalent precursor to subsequent literary experiments. Yet we
may underestimate the significance of Macpherson's poetic prose. It
is not easy to cite an earlier work of pan-European influence in
which prose is so consistently restricted to evoking a single emo-
tional tone. Macpherson attempts (often unsuccessfully) to stylize

2. Robert Rosenblum, *Transformations in Late Eighteenth-Century Art* (Princeton,
1967), p. 170. The previous quotations are from pp. 4–5 of this valuable book. See
also Persner's book cited in chapter 1, note 3, above.

his syntax as well as his vocabulary to accord with the primitive violence of his subject matter. He tries to reproduce through a language which is neither prose nor poetry a primal vigor of both the substance and form of his Gaelic originals, and in so doing he raises questions about aesthetic decorum. His rhetoric, despite—or perhaps because of—its dependence on the model of the King James Bible, calls into doubt several presuppositions about the nature of literary art, as Blake, an admirer of *Ossian,* made explicit a few years later. Wordsworth did not admire *Ossian,* but his argument that there is no essential difference between the language of poetry and prose is related to Macpherson's endeavors. Even in the brute fact of being a prose "translation" of poetry, *Ossian* tests accepted distinctions between the prosaic and the poetic.

Such testing, it seems to me, is essential to that mid-eighteenth-century complex of impulses (simultaneously antiquarian and innovative) which can be drawn together under the rubric of "historicism." I prefer this term to "linearism" for more than one reason. Historicism foregrounds the deliberate, highly self-conscious archaizing component in a movement which frequently finds expression in illustrations and "translations" of ancient works and modes. *The Fall* by the French painter Hubert Robert illustrates historicism's combining of archaism with inventiveness. Robert deliberately violates a rule of illusionistic painting by portraying what is impossible to picture in a static medium—the action of falling. Robert's scene shows a man midway in a fall from an antique monument. The protagonist is victimized by that passion for the archaic which leads the painter to lavish as much care on the antiquarian setting as on the fatal plunge itself.

Another reason for preferring the term historicism is that anti-rococo experiments included nonlinearistic techniques. Alexander Cozens, who drew some linear, surprisingly modernistic, landscapes, also developed a method for creating landscapes out of ink blots. As A. P. Oppé observed, Cozens used *either* blots *or* lines to convey "the force of life, the spontaneity of a living thing."[3] However

3. A. P. Oppé, *Alexander and John Robert Cozens* (Cambridge, Mass., 1954), p. 102. This book contains a reproduction of Cozens' *New Method.* See chapter 4, note 8, above for other discussions of blot art, which had considerable influence in early nineteenth-century British art, and not on Turner alone: Martin Hardie has reproduced a blot by Constable in *The Collector* 11 (December 1930): 186. An essay of mine in a forthcoming

antithetical as forms, blots and lines are alike in being what one might call primal modes of representation. And either mode was attractive to artists desiring to portray the essential forces, the elemental energies, of natural and human life. These forces (which of course lend themselves to sensationalism) are the principal subjects of Macpherson's translations, and the style of *Ossian* can be understood as a literary manifestation of the search for basic, primitive modes of representation, more successfully realized, in my view, by some graphic artists of the later eighteenth century. But we should not underestimate the challenge to subsequent poets posed by the popularity of *Ossian*'s ostensible simplicity. A part of Romantic poetry is in effect a repudiation of *Ossian*—on the grounds that Macpherson's subject matter is factitiously primitive and his style spuriously simple. Interestingly, there are analogous repudiations by Romantic graphic artists. Turner, for instance, arrived at a technique the reverse of Cozens' blot method. The blurriness of Turner's later canvases is an achieved vision of the unshaped *within* highly articulated forms, not a rendering of articulated forms which can be drawn *out of* an ink blot's formlessness. Such repudiations, however, are testimony to the importance of what is repudiated. Fully to understand Romanticism we have to understand its intricate relation (a complicated interplay of both inspiration and rejection) to the art which immediately preceded it, an art more complex and original than is usually admitted, and deserving extensive study.

collection honoring the late Earl Wasserman defines more concretely and in specific detail what I mean by late eighteenth-century historicism. Two articles of special value on this topic appear in *The Varied Pattern: Studies in the Eighteenth Century,* ed. Peter Hughes and David Williams (Toronto, 1971): Robert Rosenblum, "The Dawn of British Romantic Painting," pp. 189–210, and Ronald Paulson, "The Pictorial Circuit and Related Structures in Eighteenth-Century England," pp. 165–87. Of more general philosophic significance is Jean Starobinski, *The Invention of Liberty, 1700–1789* (Geneva, 1964).

Index

DESIGNED BY IRVING PERKINS
COMPOSED BY HORNE ASSOCIATES, INC., HANOVER, NEW HAMPSHIRE
MANUFACTURED BY LITHOCRAFTERS, INC., ANN ARBOR, MICHIGAN
TEXT LINES ARE SET IN ALDINE MEDIUM, DISPLAY LINES IN GARAMOND

Library of Congress Cataloging in Publication Data
Kroeber, Karl, 1926–
Romantic landscape vision.
Includes bibliographical references.
1. Wordsworth, William, 1770–1850—Criticism and
interpretation. 2. Constable, John, 1776–1837.
3. Nature in literature. 4. Romanticism, English.
5. Landscape painting, English. 6. Romanticism in
art—England. I. Title.
PR5892.N2K7 759'.2 74-5905
ISBN 0-299-06710-6

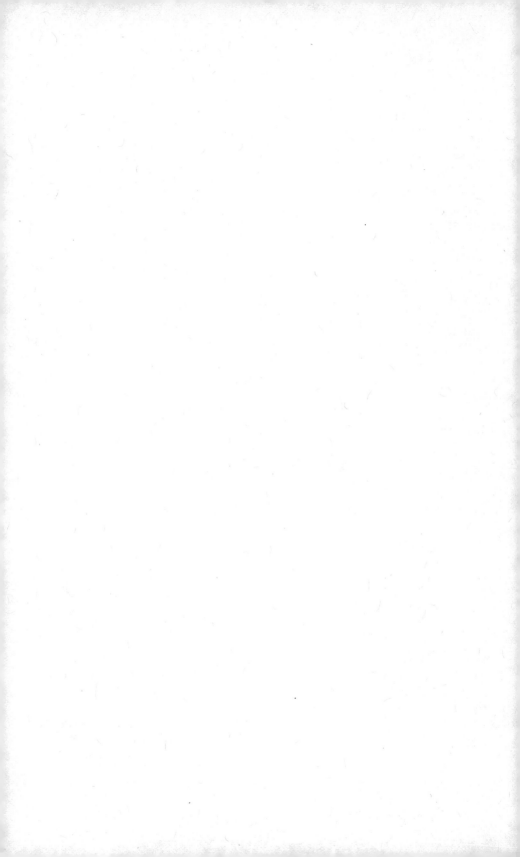